BUNGAY
THROUGH TIME
Christopher Reeve

Photographs by Martin Evans

AMBERLEY PUBLISHING

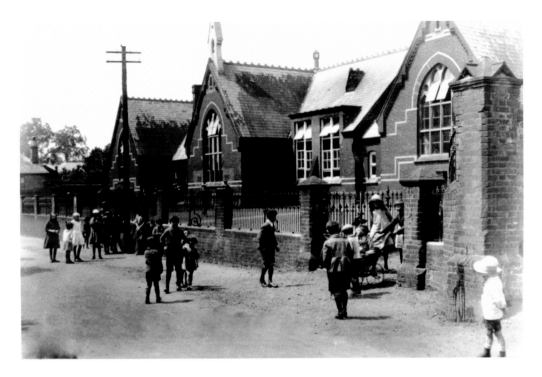

Bungay Primary School, Wingfield Street, *c.* 1900.

Dedicated to Frank Honeywood, Town Recorder 1979 – 2009, in grateful acknowledgement
for the huge treasure chest of photographs and other historic material he has collected
for future generations to enjoy.

First published 2009

Amberley Publishing Plc
Cirencester Road, Chalford,
Stroud, Gloucestershire, GL6 8PE

www.amberley-books.com
Copyright © Christopher Reeve, 2009, and
colour photographs © Martin Evans, 2009

The right of Christopher Reeve to be identified
as the Author of this work has been asserted in
accordance with the Copyrights, Designs and
Patents Act 1988.

ISBN 978-1-84868-831-5

British Library Cataloguing in Publication Data.
A catalogue record for this book is available
from the British Library.

Typeset in 9.5pt on 12pt Celeste.
Typesetting by Amberley Publishing.
Printed in the UK.

Introduction

I have written several books about Bungay, some in association with my brother Terry, and many in connection with Frank Honeywood. Every one has been a new challenge, but also a new delight, because they've allowed me to do what I enjoy most, explore and research the history of the town in which I was born.

When I was a teenager, my attitude to Bungay was very different. Like most teenagers, I longed for more excitement than Dumpsville could offer. Eagerly shaking its dust off my boots, I moved to Norwich, then Cambridge, London, St Andrew's in Scotland, and finally Bury St Edmunds, with a Grand Tour of Italy in between. But although my feet may have travelled away, my heart remained firmly entrenched in my birthplace and in 1998 I returned to live here and to re-value what I had been so eager to dispense with thirty years earlier. And I'm living again in the house where I was born, in Southend Road. It hasn't changed much in sixty years, and, free of the traffic turmoil which bedevils other parts of Bungay, it still allows children to play in the road where my brothers, sister and I enjoyed playing so many years ago.

This new book has been a particular pleasure to write, with strolls around the familiar streets to observe the historic features that survive, as well as all the changes that have taken place during the past one hundred and fifty years. *Bungay Through Time* contrasts early monochrome photographs with recent colour images, the old juxtaposed with the new. We may often moan that the town looks scruffy, or suffers from litter or graffiti, but it's apparent, from some of the images depicted here, that it looks smarter, brighter and better maintained than it did in the earlier centuries, when horse manure lay in the streets, the roads were rough and un-made, and houses and shops had none of the sparkling paint and smart new windows, doors, and floral displays that we see around us today.

The oldest pictures in this book were taken by Ambrose Boatwright, Bungay's first professional photographer, who had a studio in Earsham Street in the 1860s. The modern colour photographs are by Martin Evans. While I was snugly tucked in my study, scribbling the captions, Martin was out risking life and limb, attempting to match the old images we'd selected with the new. Gawped and gesticulated at by shoppers, abused by cyclists, jostled by lager louts, hissed at by cats, and almost mown down by Bernard Mathews lorries, this book could have been a memorial to a hero who died in action for the benefit of his fellow Bungayans. Fortunately he survived, weary, battle-scarred, but intact, and it's to Martin that the credit must be given for creating such a vivid array of 'afters' to match the 'befores', the ice-cream after the pork-chops.

This book, however, is primarily a homage to Frank Honeywood, who, from 1979 to 2009 was the Town Recorder and during those thirty years amassed a tremendous collection of thousands of images of Bungay. Some are Victorian ones, donated or purchased. Many are more recent ones, loaned by local people for Frank to copy. Others were created by Frank himself in his frequent walks around the town to record changes. He was also assisted by Sean Leahy, who worked with Frank in creating many images of enduring value. Frank retired from his official role as Recorder this year. His successor is Albert Thwaites, who is well known for his work with Bungay Camera Club, and for the Festival photography exhibitions he helps to organise in St Mary's Church.

The Honeywood collections, now mainly housed in Bungay Museum, are so large and comprehensive that you'd think they must contain every image of Bungay ever taken. But new ones keep turning up, and every time I go to visit Frank, he'll say to me, with a twinkle in his eye 'Have you seen this one?' – and out will come, not one, but a dozen different photographs recording aspects of old Bungay that I never knew about. All the 'old' photographs depicted in **Bungay Through Time** are from Frank's collections. So Frank, this book is gratefully dedicated to you. For many years you've suggested 'Why don't we do a book of *before's* and *after's?'*

And now we've done it.

Christopher Reeve, 2009

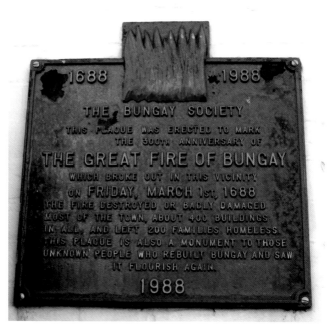

Fire Plaque and Roof Boss
In 1688, Bungay was devastated by a fire which started in a tenement in the Market Place, and rapidly spread throughout the town. Within the space of six hours many buildings were destroyed or severely damaged, and nearly two hundred families were left homeless. The resourceful townsfolk soon raised funds for restoration, and as a result, by the eighteenth century, Bungay became a fashionable modernised resort boasting a wide range of attractions. A roof boss in the south aisle of St Mary's church records the year when the church was rebuilt, and in 1988 a commemorative plaque was erected on the Farmhouse Bakery building where it's thought the fire may have started.

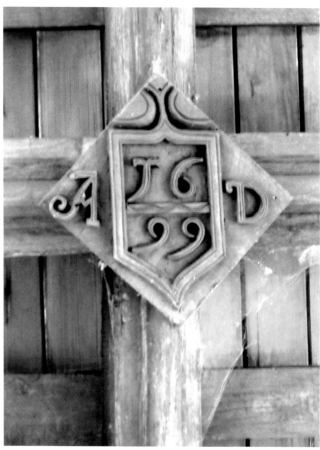

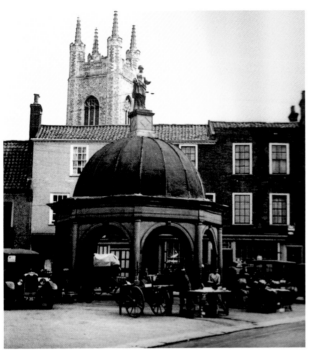

The Market Place and Butter Cross

The market place was established in the thirteenth century, and remains the ancient heart of the town community. A covered Market Cross was provided to shelter traders, but perished during the Great Fire which devastated the town in 1688. The present building was erected soon afterwards. Few stalls are visible in the photo of the 1930s, so it's clearly not Thursday, Market Day, but the colour image confirms that, despite the impact of modern superstores, open-air markets remain popular.

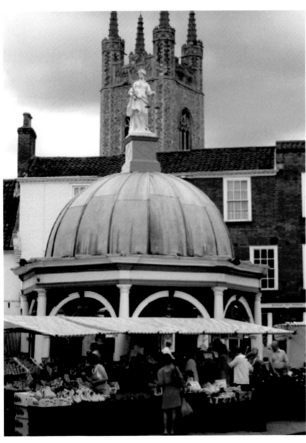

Market Place and St Mary's Street

An early stereoview, *c.* 1860, by Ambrose Boatwright, Bungay's first professional photographer. At this date the town centre seems to have only roughly surfaced roads, and stone-paved crossings have been provided to keep pedestrians' feet and the ladies' long skirts protected from puddles and dirt. The horse and cart on the left recapture a more leisurely pace of life, contrasted with the busy traffic scene of today.

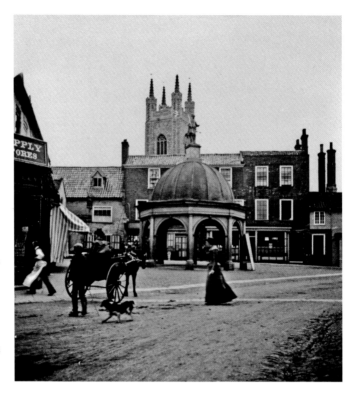

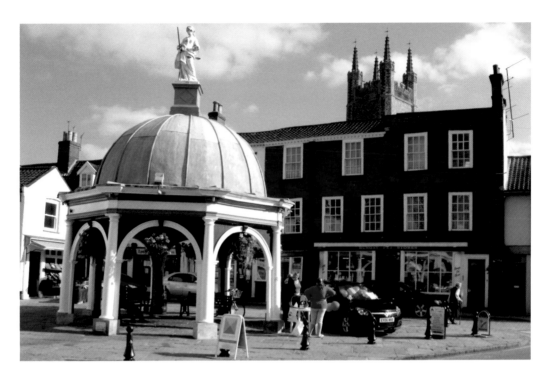

Bungay Baby Welfare Week

An initiative to help mothers raise healthier children was organised in 1932, with a week of varied events. A temporary health centre was established where information and advice could be obtained. The photo depicts mothers and children assembling for a 'Best Baby' competition at the Butter Cross. A recent fund-raising event organised by young mothers is depicted in the same area outside the Bungay Pet Stores.

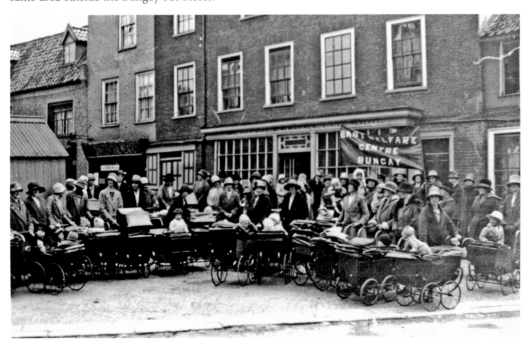

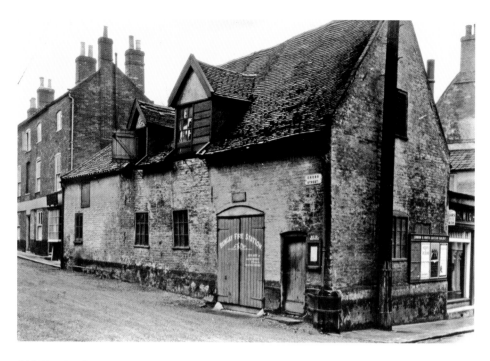

Old Fire Station

The old Fire station in Cross Street behind the Market Place. The building housed the fire-engine, and originally also the horses, which carried the local fire-fighting crew to wherever their help was needed. The Fire Station moved to Upper Olland Street in 1930, and Wightman's drapery and furniture store extended their premises onto part of this site. Not long after the extension was completed, the Second World War occurred, and the building suffered severe bomb damage.

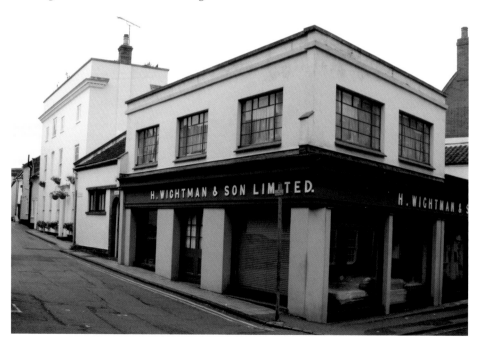

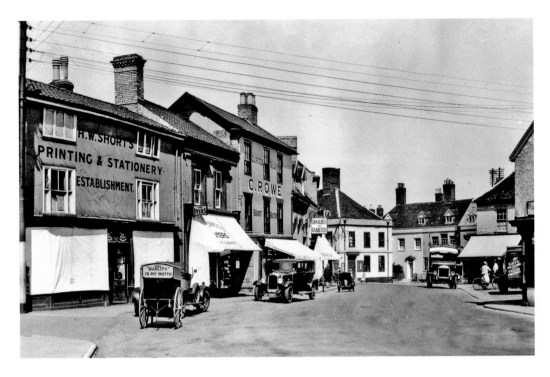

Market Place With Motor-Bus

Obviously a scorching hot day, when the local shop-keepers – Short's, Rowe's, and Ball's – needed to protect their goods from damage by the sun. A motor-bus is parked near the Butter Cross, and nearby, a barrow-cart bearing the sign, 'Quality is My Motto'. Unfortunately, what it contains is not revealed. Perhaps a few herrings, rotting in the heat? Today, instead of delivery barrows, the town centre is congested with giant-sized delivery lorries.

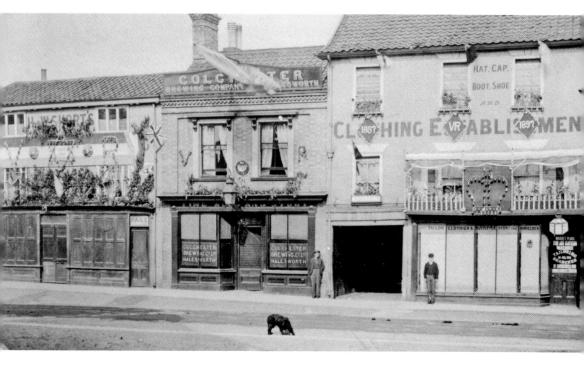

Market Place Celebrations

In 1897 the town celebrated the Diamond Jubilee of Queen Victoria. The photograph seems to have been taken on a Sunday as all the shops are closed and shuttered. The central building is the Bell Inn, which closed in 1920. It's now occupied by the Farmhouse Bakery, and the plaque commemorating the Great Fire can be seen on the wall to the right of the door.

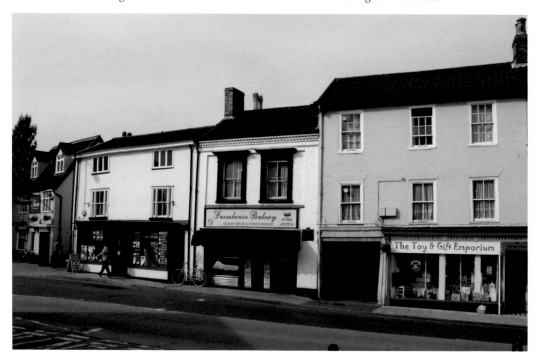

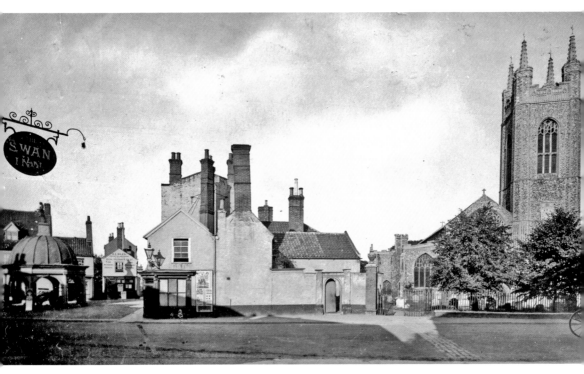

Corner of St Mary's Street and Market Place
The early photo of *c.* 1900 depicts St Mary's, the town centre church, with a granite crossing over the roughly surfaced road. This wonderful wide angle view even includes the hanging sign of the White Swan, on the left. Today, a zebra-crossing is situated here, for the safety of pedestrians, but an early granite slab crossing still exists at the junction of Outney Road and Webster Street.

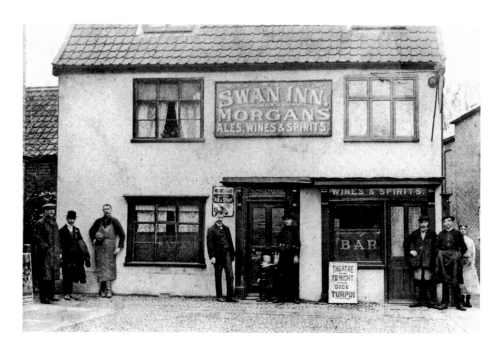

The Swan Inn, Market Place *c.* 1911

The publican and assorted customers are posing for the camera, and a poster advertises a Dick Turpin play at the Corn Exchange in Broad Street, now the renovated Fisher Theatre. The building has recently been painted and re-furbished, and regained the name of the White Swan. For several years previously it was known as 'Swansons' probably to attract a younger and more lively set. Unfortunately they proved a bit too lively, so the new image may attract a more genteel clientele.

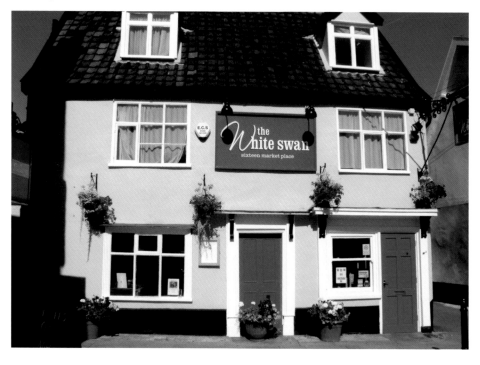

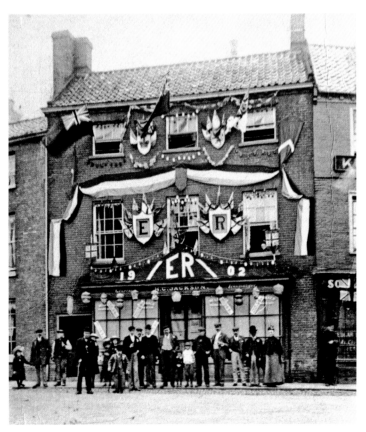

H. G. Jackson's Store, Market Place.
The premises have been gaily decorated with flags, bunting and Japanese lanterns, to celebrate the Coronation of Edward VII in 1902. As with many early photos when a cameraman in the street was a novelty, a crowd has assembled to smile sweetly. Today, the 'Hobby Horse' shop in the same premises, adds a sparkle to the town centre, selling a colourful array of children's clothing, embroidery items and gifts.

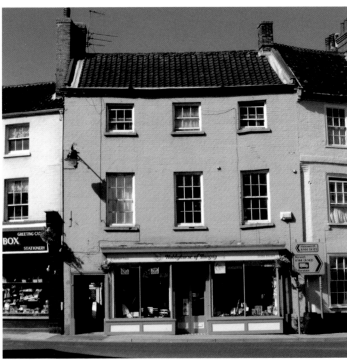

The Craft Shop, Market Place, 1981
The shop was popular in the 1970s
selling a wide variety of craft goods
made by local people. The proprietor,
Freda Roe, stands in the doorway.
Today the building is part of Lloyds
TSB.

In the medieval period the market
place only had trader's stalls, but
gradually more were developed into
brick buildings to provide permanent
shop and dwelling space. The Craft
Shop and Alex's Fruit & Veg next door
to the alley seem to be examples of
small buildings that developed in this
way.

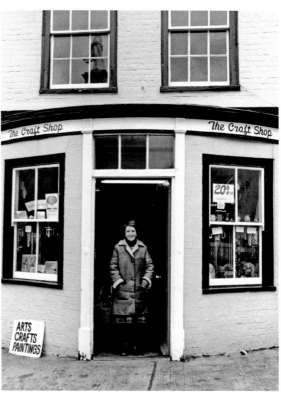

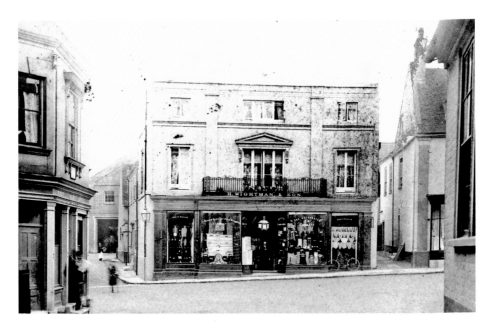

H. Wightman & Son Ltd. Market Place *c.* 1900

The shop, established in 1861, displays an array of drapery, stockings and knickers filling the large windows. The Post Office stands on the corner of Bridge Street, and along Trinity Street on the left can be seen the open doors of Owles' Warehouse. Wightman's continues to flourish today as a popular family business.

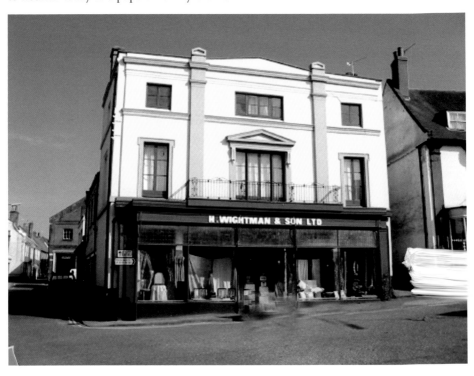

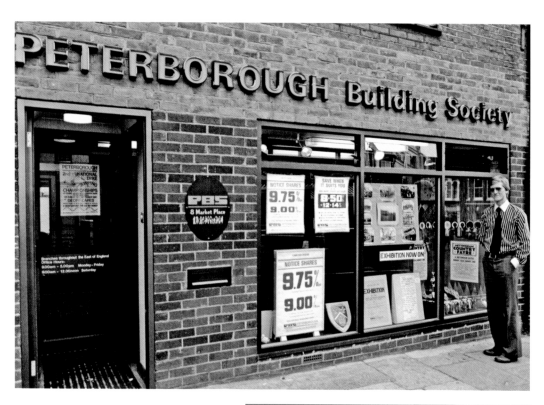

The Norwich & Peterborough
Building Society, 1981
No. 8, Market Place, with the
manager, Stephen Honeywood
standing nearby. The photo is
by Sean Leahy, who has made a
valuable contribution to the Frank
Honeywood collection of images
in Bungay Museum. Today, the
premises are occupied by D. R. Grey,
Opthalmic Opticians & Contact Lens
Practitioners.

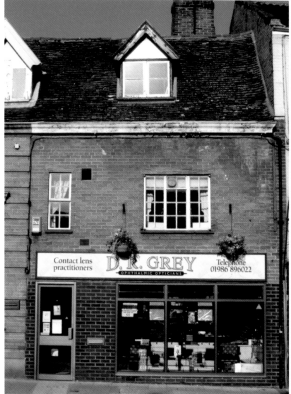

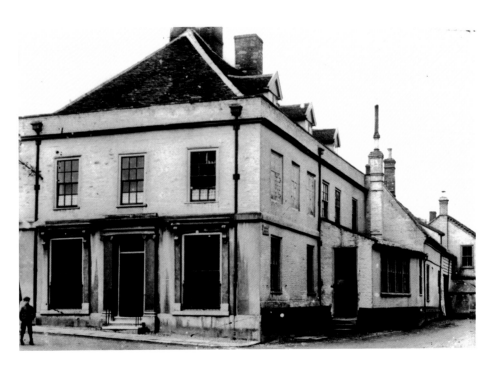

The Three Tuns, Market Place
One of the town's ancient coaching inns, the building dates back to Tudor times or earlier. It was damaged during the Great Fire which broke out in the Market Place in 1688 , and largely rebuilt, although the cellars and other sections survived. In the eighteenth century it was in competition with the King's Head opposite to attract a fashionable clientele for its Assemblies and Balls. In c. 1920 it was owned by a local builder and architect, John Doe, who made substantial alterations.

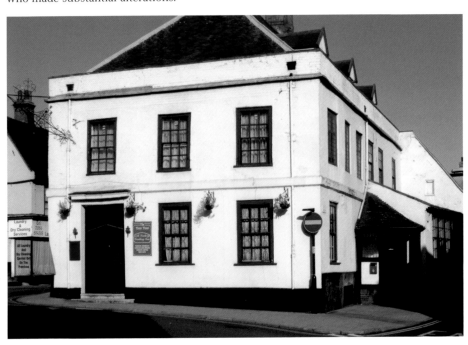

The Town Pump, Market Place

In the photo of *c.* 1920, the pump is being operated by two men collecting buckets of water. A pumped water supply was not provided to local houses until 1923, so townsfolk had to rely on pumps or wells situated closest to their property. The pump survived until 1933 when it was replaced with a lighting standard surmounted with a weather-vane representing the famous 'Black Dog'. More recently, the Bungay Society provided this elegant jardinière to add a splash of colour to the Market Place.

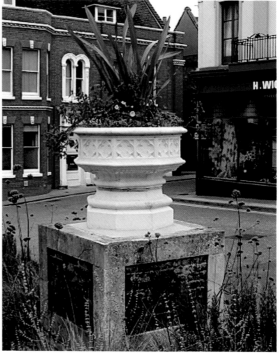

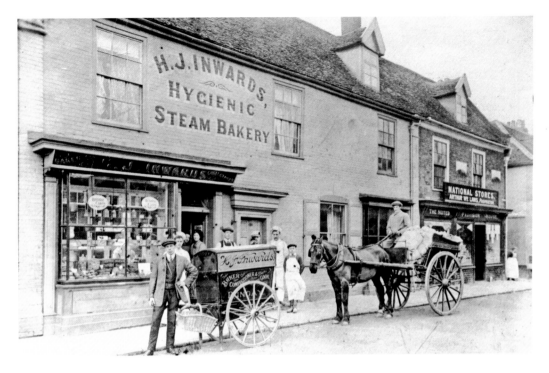

St Mary's Street, H. J. Inwards Hygenic Steam Bakery

This scene of *c.* 1900, shows the staff employed by Inwards's Bakery posing in front of the premises: the youth with the hand-cart, an older man with the horse and cart for delivering sacks of flour, and the bakery staff wearing white aprons. A new range of shops now replaces the Bakery, and the cars and zebra-crossing indicate the change from horse-power to motor vehicles.

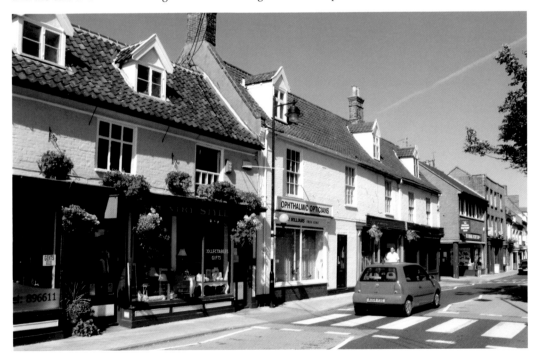

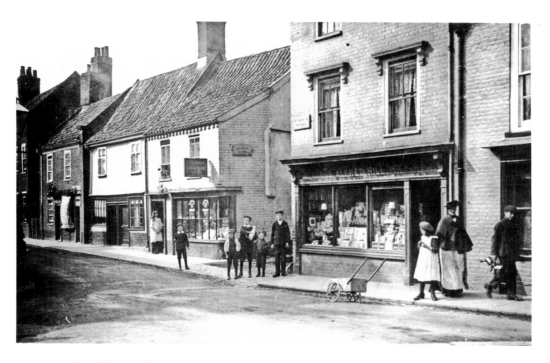

Junction of St Mary's and Upper Olland Streets

A group of boys has paused to stare at the camera, at the entrance to Priory Lane. One of them is perhaps in charge of the small hand-cart in the fore-ground. Hand-carts of all sizes were a prominent feature of street-life in the early twentieth century. Whereas the shops were trading prosperously in the earlier photo, today the impact of the current economic recession is indicated by empty windows, and the signs 'For Sale', or 'To Let' – but not for long!

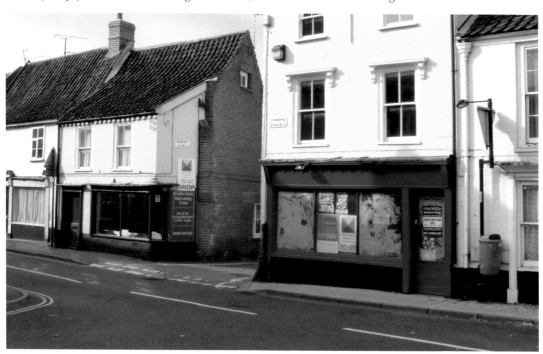

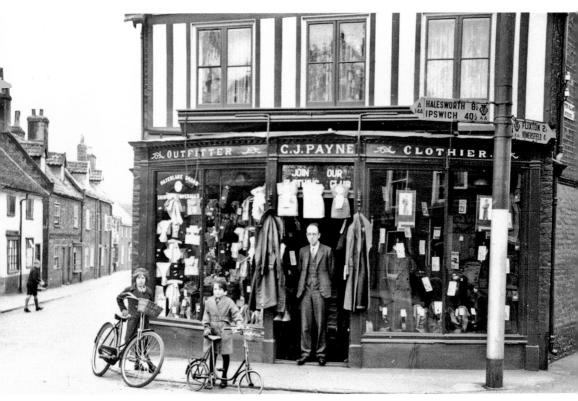

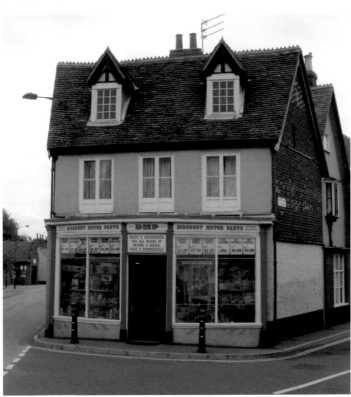

Junction of Upper and Lower Olland Streets
The neatly dressed shop manager, Mr C. J. Payne stands in the door of his Outfitter's & Clothing business. He looks rather glum. Perhaps it's the end of the day and he's only sold a sixpenny handkerchief. Today, suits are out, and Discount Motor Parts are in. The building was one of the few to survive the Great Fire, and some of its sixteenth-century features can be seen in the colour photo.

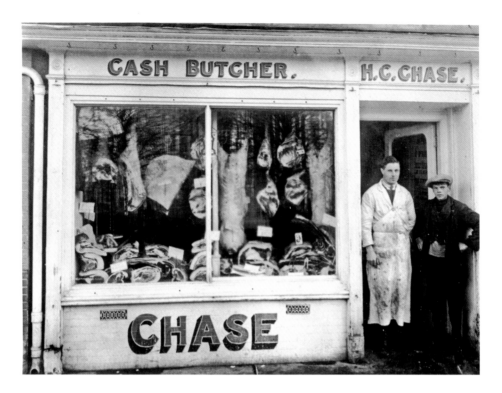

Chase's Pork Butcher's Shop

This was the 'Cash Butcher' shop attached to the Fleece Inn in St Mary's Street, but the Chase family had a larger shop in Trinity Street where presumably meat could be bought 'on tick'. In 2000, after the shop had closed , it was acquired by Adnams' brewery to provide a games room for the pub. Laurie King the licensee, is depicted examining the timbers revealed during renovation, which prove that the building dates back to the early sixteenth century. (*Photo: Bill Darnell, courtesy of Archant newspapers*)

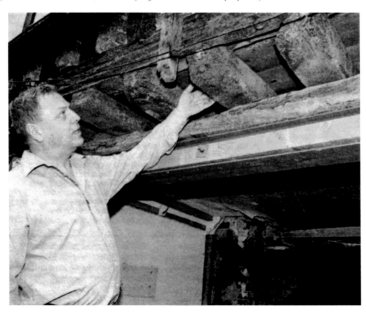

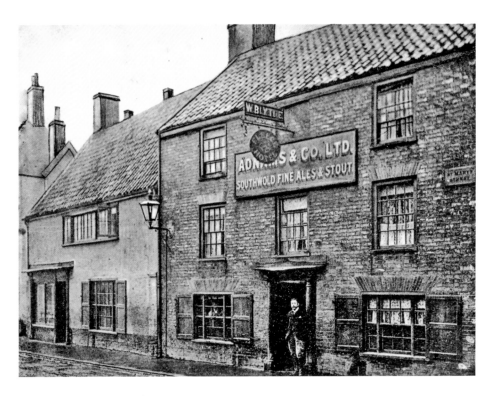

The Fleece Inn, St Mary's Street

For more than a hundred years this has been an Adnam's pub, and the sign advertising its 'Southwold Fine Ales & Stout' can be seen over the door. In the early twentieth century the façade was renovated in mock-Tudor style by local builder John Doe. Today the Fleece regularly wins prizes for its floral displays in the annual Bungay in Bloom competition.

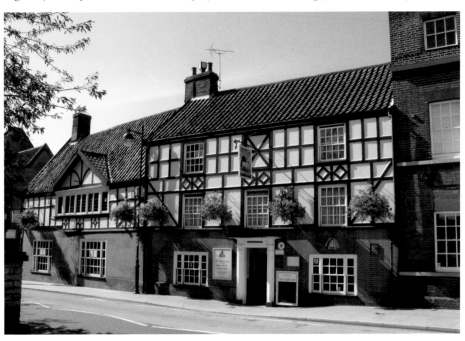

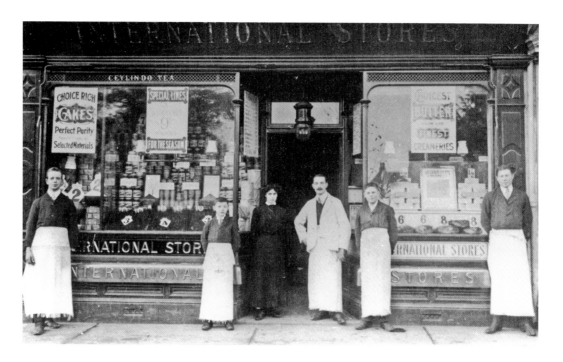

International Stores, St Mary's Street
The staff, wearing long white aprons, pose in the doorway of the food store, which is situated in part of the town's ancient Guildhall dating back to Tudor times. Today, the building remains a food store, Londis. The door frame on the right has recently been vandalised and is awaiting renovation.

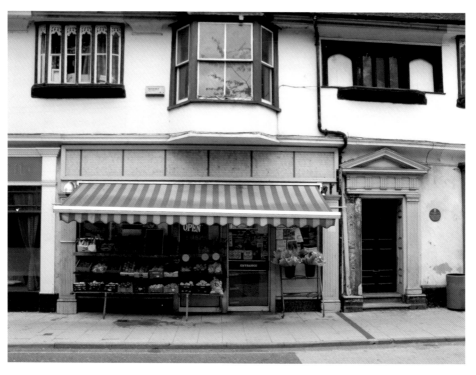

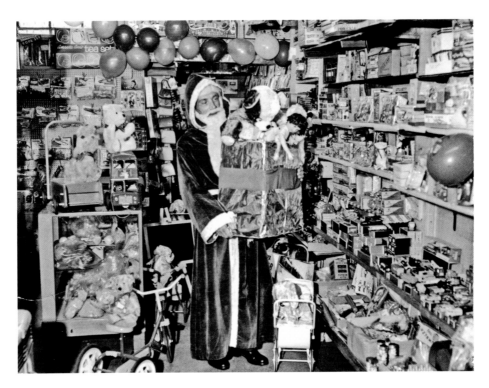

Spashett's Newspapers & Toyshop, St Mary's Street, *c.*1960
Spashett's opened in *c.* 1940 and this is the rear area Toy Department. Father Christmas is busy packing a box of Christmas toys for 'good' children. Bungay's only toy shop today is the Toy & Gift Emporium in the Market Place, where owner Mary Seamons is busy arranging the colourful displays.

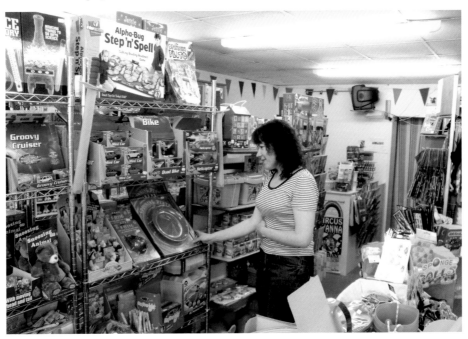

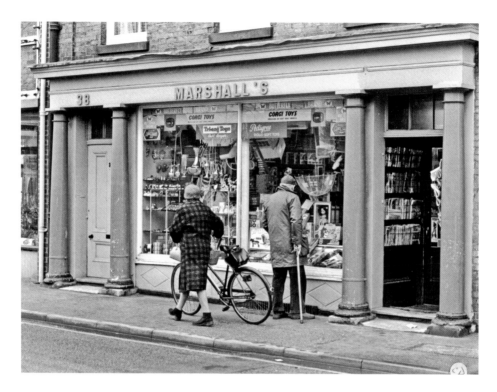

Exterior of Marshall's Shop, *c.* 1980

Marshall's replaced Spashett's in *c.* 1970. Displays of newspapers and magazines can be seen inside the doorway. Today the shop is Martin's Newsagent. The façade has been altered, with the two doors removed and a central one added, but it still retains the attractive Victorian pillars. Today, the windows are used for posters advertising prices, rather than to display goods, as can also be seen in the Factory Shop next door.

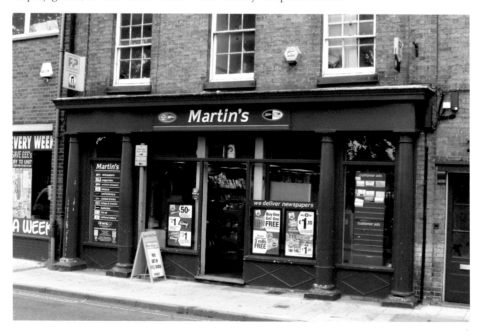

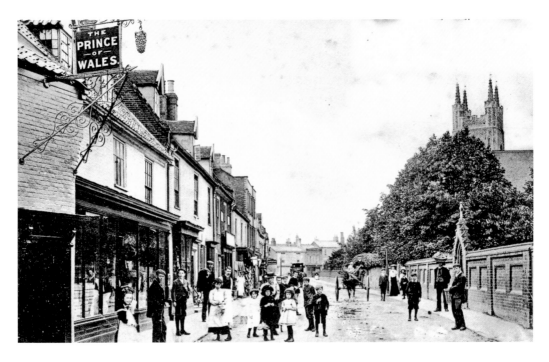

St Mary's Street, c. 1900

It seems that everybody wants to stop and gaze at the camera-man, not just the children, but also the man driving the horse and cart, and the delivery man with a basket of goods on his head. Nobody took much notice of our modern camera-man as he tried to dodge in and out of the traffic. On the left can be seen the Prince of Wales pub sign, and on the right the Catholic School and church.

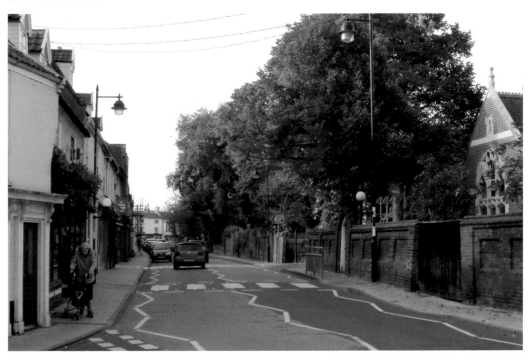

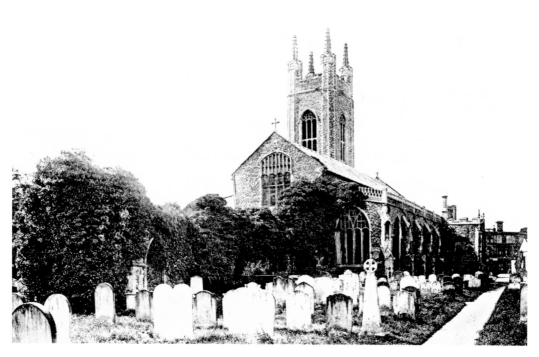

St Mary's Church and Priory Ruins

The church was attached to the medieval Benedictine priory, built in the late twelfth century, but became a parish church when the priory closed in 1536. Whereas the church flourished, the priory was allowed to fall into ruin, and was probably also pillaged for its stone for various building works. The ruins have been partially restored recently, and the ivy which smothered them removed.

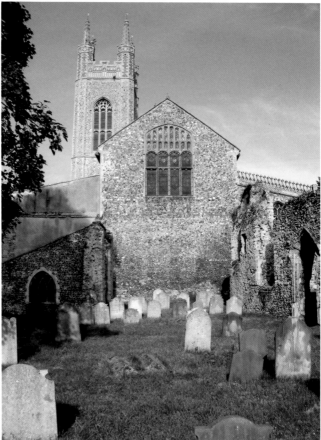

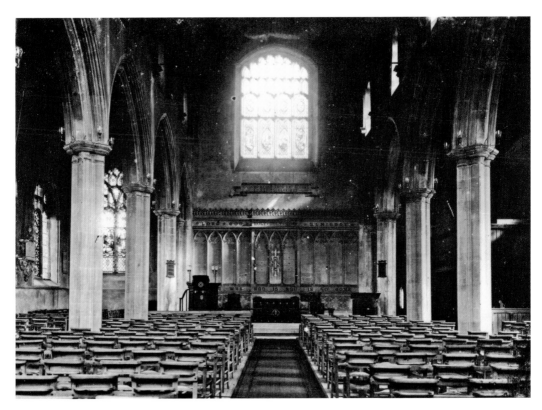

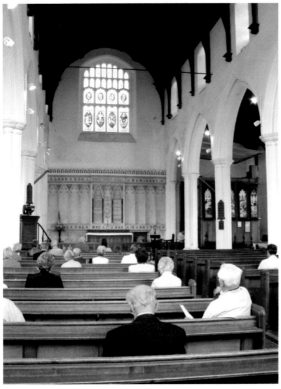

St Mary's Church, Interior
The early photo, *c.* 1900, depicts the
chairs which surprisingly, replaced
the original pews in the Victorian
period. The church closed for regular
worship in 1978, and is now in the
care of the Churches Conservation
Trust. The organ has recently been
restored with bequests from the late
Kathleen Bowerbank and former
Chairman of the Friends of St Mary's,
Joyce King, and this recent picture
depicts the audience enjoying a recital
by organist Nigel Brown.

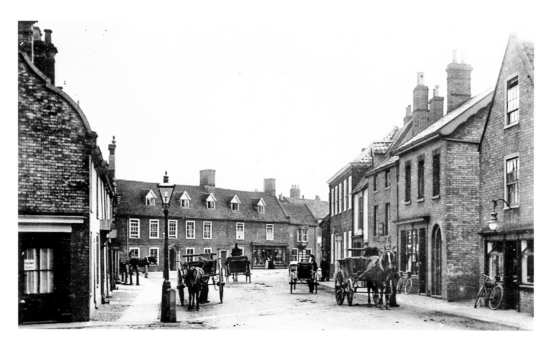

Horsepower in Earsham Street, 1911

A wonderful image of the horse-drawn carts which a hundred years ago were a familiar sight in the streets. The cobbled areas of the pavement on the left have recently been renewed, and can be seen in the Cork Bricks corner in the colour photo. The red brick buildings on the curve of the street were some of the first to be built after the Great Fire of 1688.

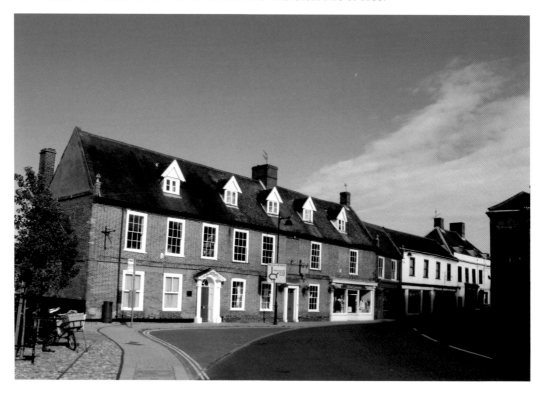

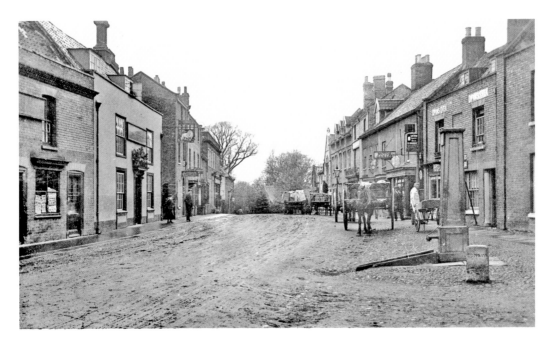

The Castle Inn, Earsham Street

This photo can be dated to *c*. 1909, just after the Fishmonger's Arms pub, on the left next door to the White Lion, had closed. Note the pump and the milestone near the junction with Chaucer Street. Although no cars are visible a motor garage sign is displayed on the building on the right. The White Lion is now the Castle Inn, which this year won awards both for its cuisine and for its floral displays in the Bungay In Bloom competition.

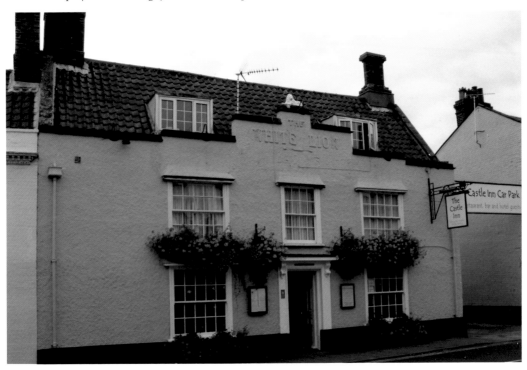

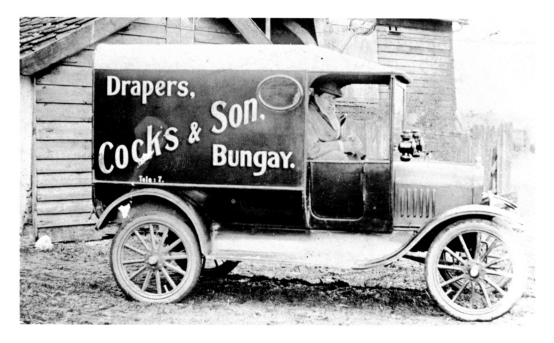

Cock's & Son, Advertising Van

Cock's & Son was a department store next to the Post Office in Earsham Street. Its display van is contrasted with the bike, with its basket of flowers, parked in the cobbled area of Cork Bricks, an inventive way of promoting the Castle Inn.

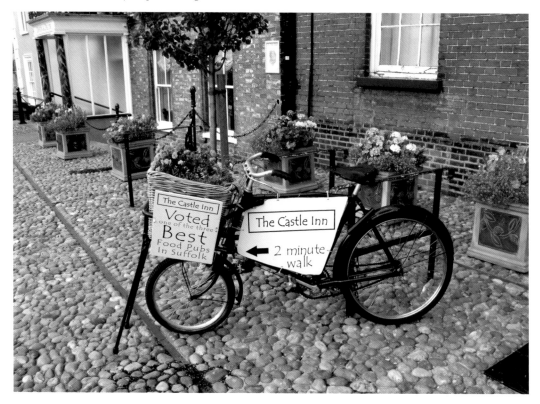

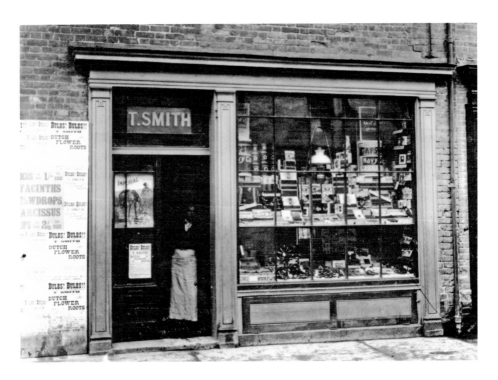

T. Smith, Tobacconist's, Earsham Street

The shop sold flower and vegetable seeds, and Dutch bulbs, as well as tobacco and snuff . The proprietor can be seen standing in the doorway. Today the shop is an estate agents, Musker & McIntyre, and despite the current recession, the property market seems to be reasonably buoyant. That's because Bungay, the 'jewel in Waveney's crown' remains such a popular place to live in!

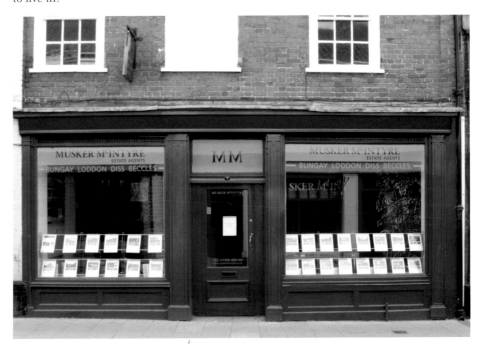

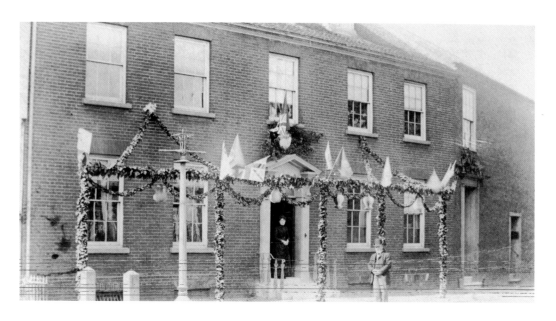

Earsham Street House

The house is decked with flags and bunting, perhaps to celebrate the Coronation of Edward VII in 1902. At this time it was owned by Frederick Smith, a solicitor. It backs onto Broad Street, where the rear premises are now occupied by the Waveney District Council offices and Museum. The rest of the building has been converted into flats.

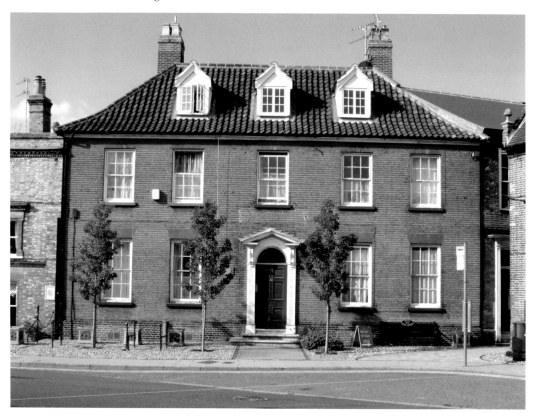

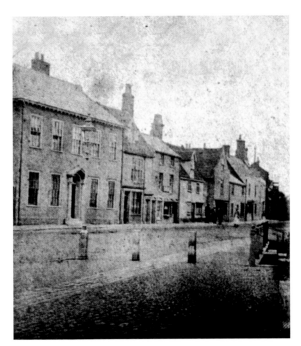

Earsham Street and Castle House
Another of Ambrose Boatwright's wonderful stereoviews of the 1860s, depicting Victorian gas-lamps and bollards, even more atmospheric when examined in 3-D through a stereoviewer. Castle House with its warm red brick, is one of the town centre's most elegant buildings.

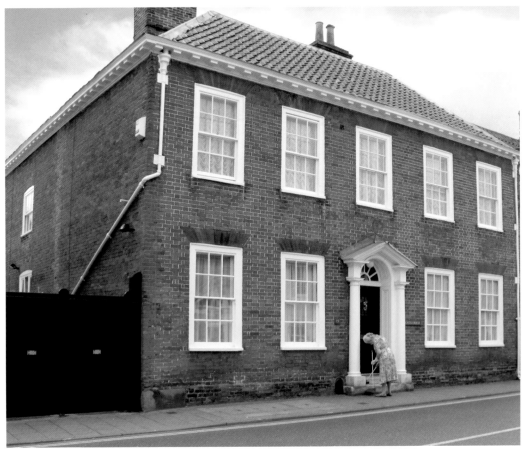

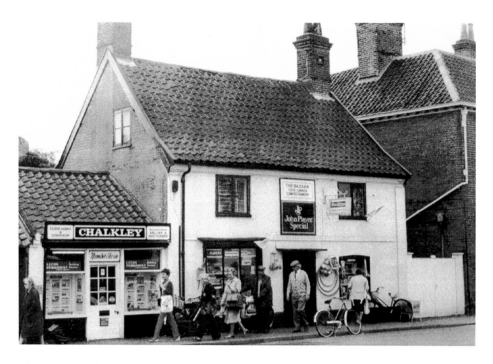

The Bazaar and Earsham Street Café

The Bazaar sold confectionery, tobacco and toys, and like Marshall's shop in St Mary's Street was an Aladdin's Cave of wonders for children at Christmas time. Today the building houses the Earsham Street Café which has established a great reputation attracting diners from all over the region. Another 'bootiful' boost for Bungay.

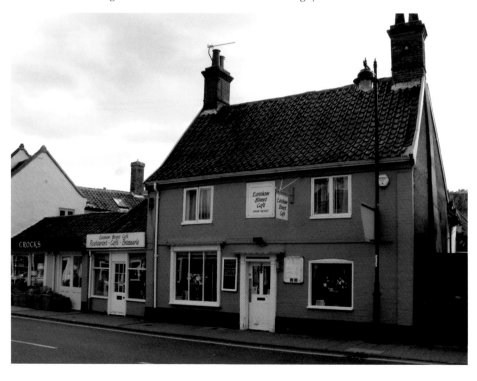

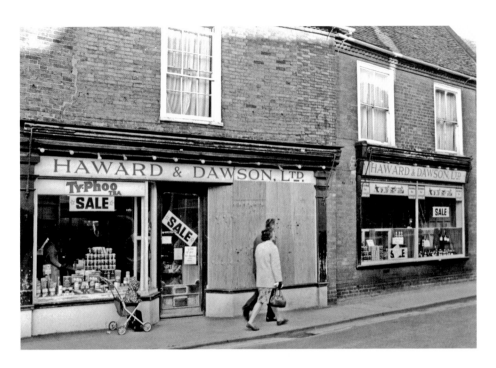

Haward & Dawson's, Earsham Street, 1977

The grocery store looks rather run-down with its boarded-up window and Sale notices. The photo was taken shortly before it closed in *c.* 1980. Since then, the building has been occupied by a number of different businesses, and today it displays the chic ladies' fashions of Four Seasons. Note the 'pink pavements' which caused an outcry when they were laid by Suffolk County Council a few years ago, but thankfully have now toned down in colour.

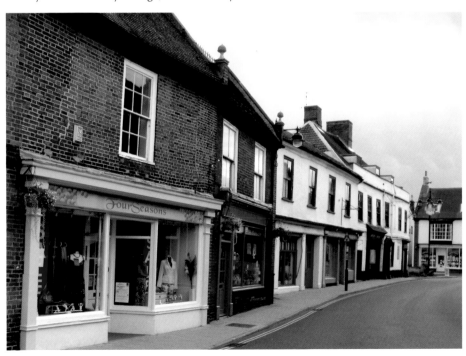

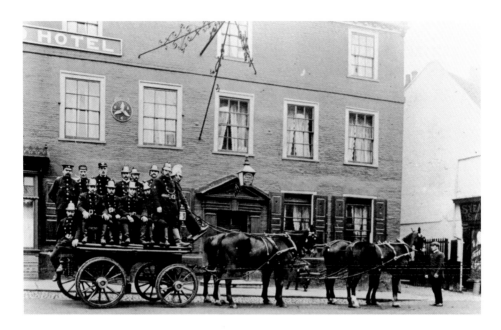

The King's Head

Together with the Three Tuns, the King's Head has been for centuries a major part of the town's life, providing accommodation, hospitality and entertainment. It dates back to Tudor times, and was rebuilt after suffering damage during the Great Fire. The photo depicting the Fire Brigade is *c.* 1900, and although the King's Head has changed little in appearance since that time, the Fire Brigade has changed a lot!

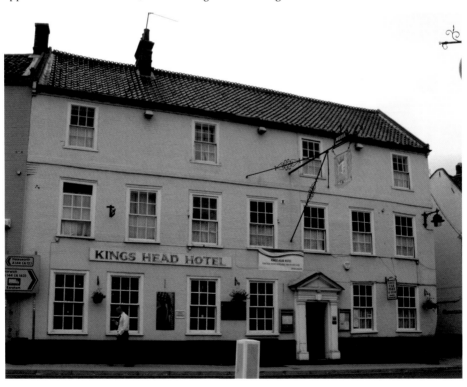

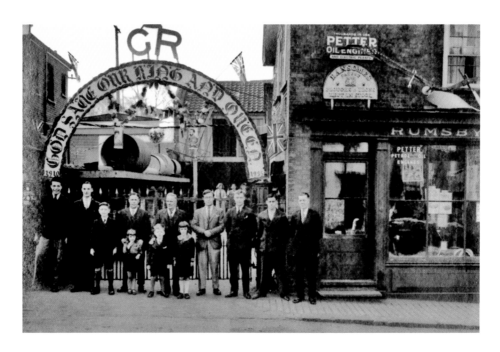

The Waveney Ironworks, Earsham Street

The business was established by Daniel Cameron in the early nineteenth century, and later owned and managed by the Rumsby family at the end of the Victorian period. The building features festive displays to celebrate the Silver Jubilee of George V in 1935. The works yard to the rear is now occupied by houses, including the Nathan's Yard cul-de-sac, which can be seen to the left of the Kitchen & Bathroom Studio.

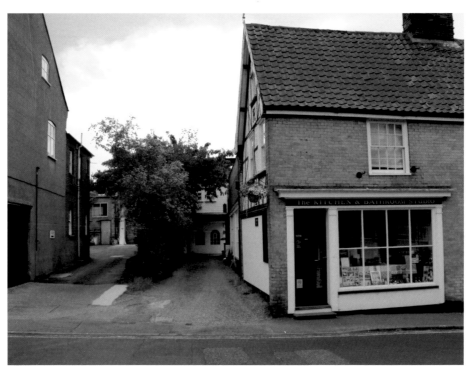

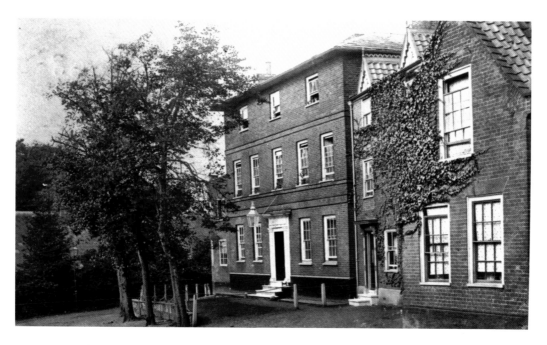

St Mary's School

The school was founded by the Miss Maddle sisters, Jane and Maude in 1885, and with a growing number of pupils moved to this spacious Georgian house in 1891. Originally only girls were admitted but later it became a 'prep' school for boys, and by the 1950s had an average attendance of 180 pupils. It closed in 1966, and is now a residential home for the elderly.

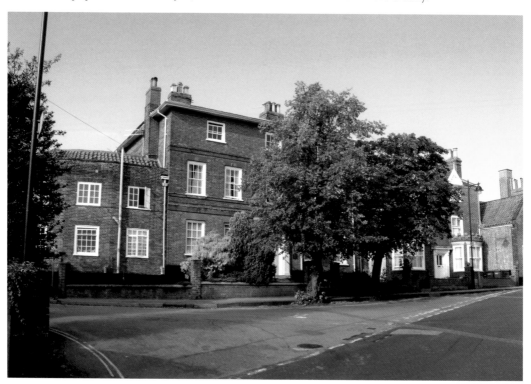

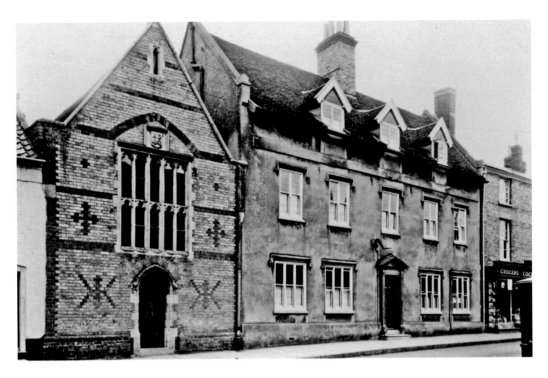

The Old Grammar School

Established in St Mary's churchyard in 1565, the school later moved to these larger premises. The building was severely damaged during the Great Fire of 1688, and rebuilt. In 1925 it moved to a new site in St John's Road, with spacious playing fields. The old school was demolished in 1937, and the Post Office was built on the site in 1940.

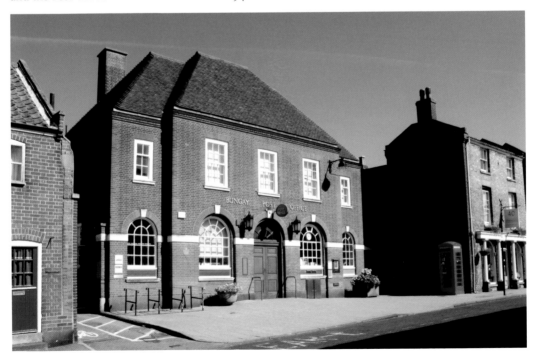

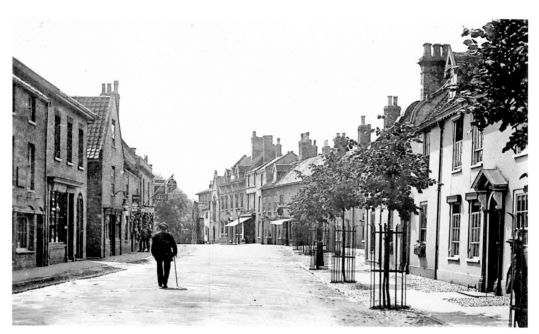

Earsham Street *c.* 1900, With a Row of Trees Stretching to Chaucer Street

The old Grammar School can be glimpsed on the right at the end of the street. The area around Cork Bricks has recently been renovated by Waveney District Council with support from the Bungay Society. New cobbles were laid, and the Callery pear trees planted, which together with the flower containers provided by Bungay in Bloom has resulted in a very attractive corner of the town.

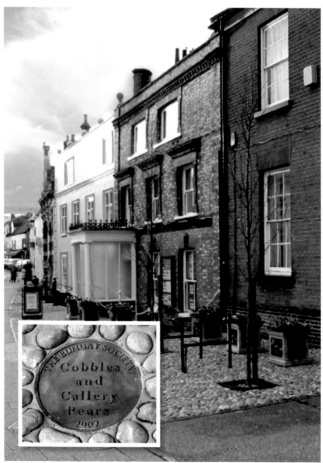

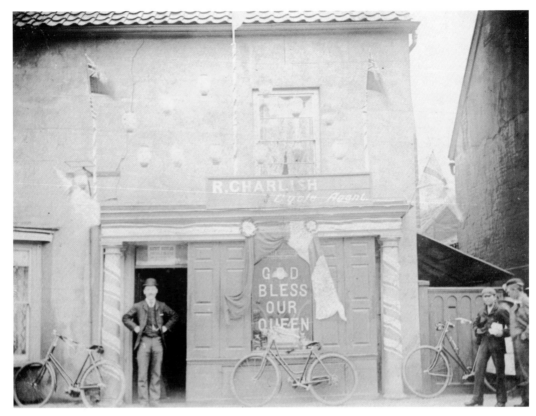

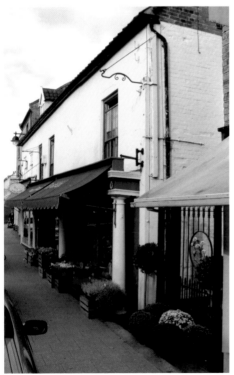

R. Charlish, Cycle Agent, Earsham Street
This small cycle shop with its quaint Victorian shutters is decorated with flags, crepe-paper trimmings, and Japanese lanterns to celebrate one of the Victorian jubilees, probably in 1897. Three of Mr Charlish's bikes have been lined up to enhance the display, and he is dressed in his Sunday best. Today the property is New Beginnings flower shop, and the quaint Victorian shutters have disappeared.

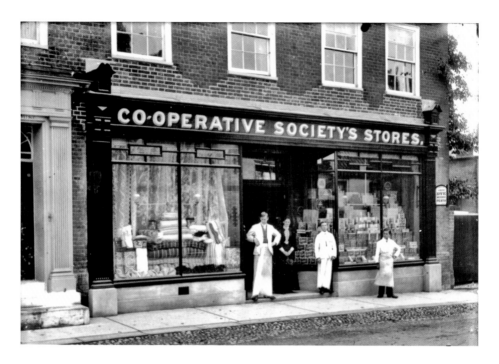

Co-operative Society Stores, Earsham Street

The windows display drapery, but a variety of other goods were sold as well. By the 1950's the main Co-op store was in St Mary's Street (now the Factory Shop) and sold virtually everything you could need. Note the smart paving in front of the store, with the old cobble-stone edgings. The property is now occupied by Black Dog Antiques, and the handsome Georgian doorway has been replaced with a modern glazed one.

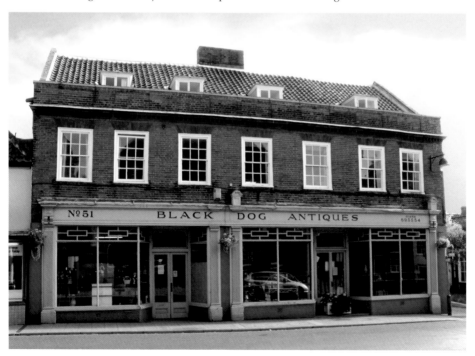

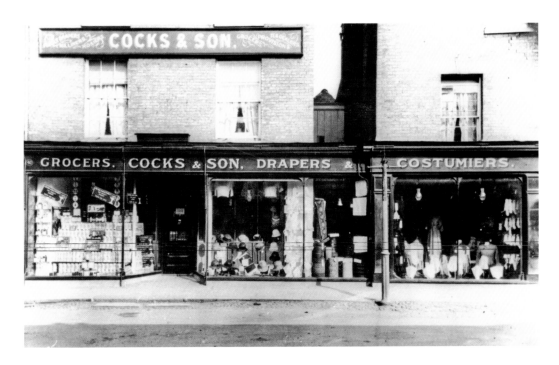

Cocks & Bells

Next door to the Post Office in Earsham Street, Cocks & Son was a department store selling drapery, clothing and groceries. The displays include ladies' stylish cloche hats and straw boaters, underwear and stockings. The business was in competition with Wightman's store in the Market Place, but in the early twentieth century, most residents shopped in town, so all traders could prosper. Today the building is divided into two shops, 'Bells of Suffolk', and 'Madame Butterfly'.

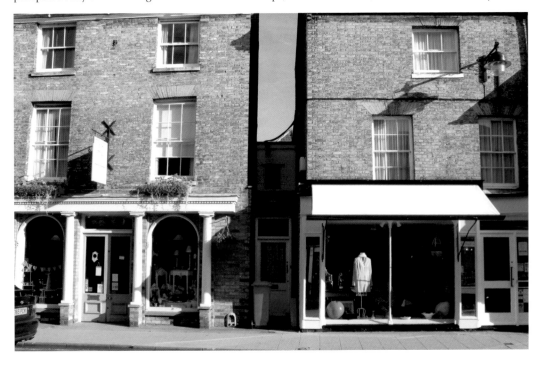

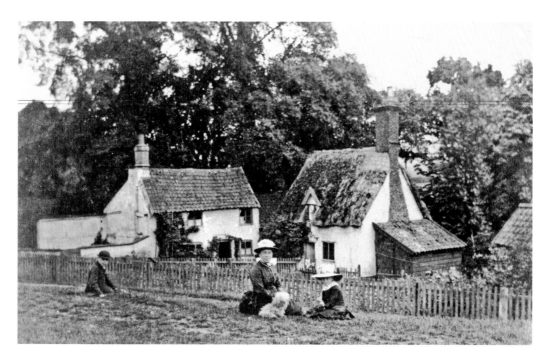

Outney Road

The road leads to Outney Common, which has been the town's grazing and recreational area for centuries. These two cottages on the Drift appear to be in a peaceful rural setting, but in *c.* 1860, when the photo was taken, the railway station had been built near the entrance to the Common. More recently, part of the same site has been taken over for parking by Clays book-printing business. The left hand cottage has been extended and enhanced in recent years.

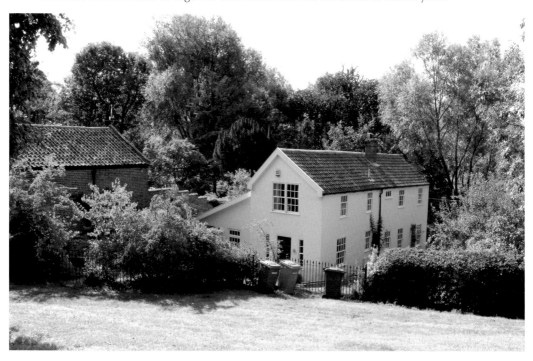

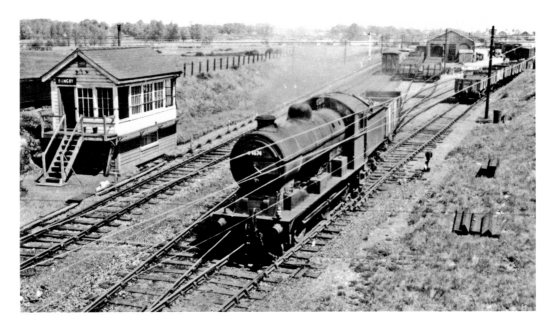

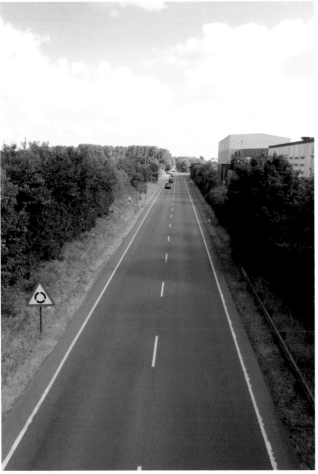

The Goods Yard, Railway Station

The Goods Yard was situated at the end of Broad Street which runs parallel to Outney Road. The signal box can be seen on the left, and trucks waiting to be loaded in the rear. This was a busy and noisy part of the town until the rail station for both passengers and goods finally closed in 1964. On 19 November 1983, the Bungay Bypass road was officially opened on part of the old rail track.

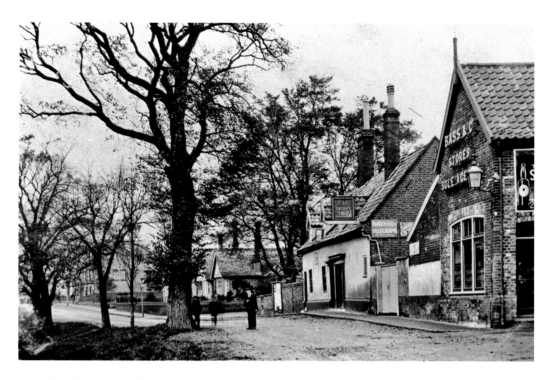

The Cherry Tree Pub

The pub stood next to the Bass & Co. Beer Stores on the corner of Scales Street. It was the closest pub to the railway station and provided welcome refreshment for many travellers. Today, both the Cherry Tree and Bass Stores have been converted to residential properties, and other signs of the times are the parked cars and coloured wheelie bins.

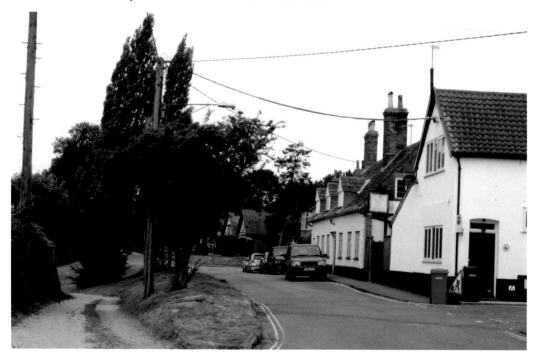

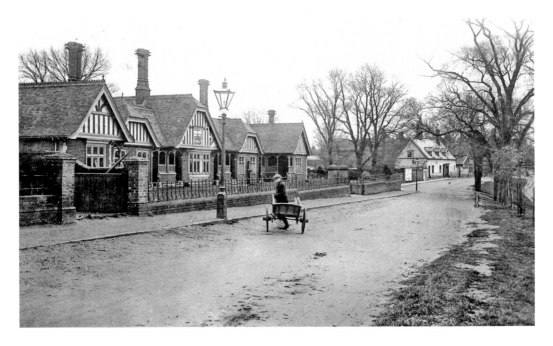

St Edmund's Almshouses

The Almshouses designed in attractive mock-Tudor style were built by Frederick Smith a wealthy Bungay solicitor in 1895. The boy with the delivery barrow who should be busying himself with his master's business has paused to gawp idly at the camera. Alternatively, he could have been paid a farthing by the photographer to pose. The Almshouses are owned by the Town Trust who look after the needs of the residents, and maintain the attractive gardens.

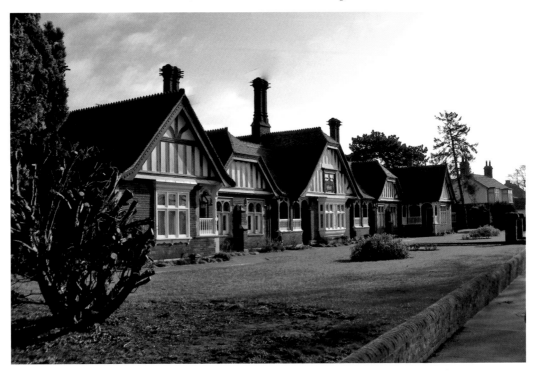

Scales Street

The row of houses was demolished in 1982 to provide space for a town car-park adjacent to Chaucer Street. Broad Street can be seen in the background. On the opposite side of the street, closer to Outney Road, are the stylish houses designed by architect John Doe in the early years of the twentieth century.

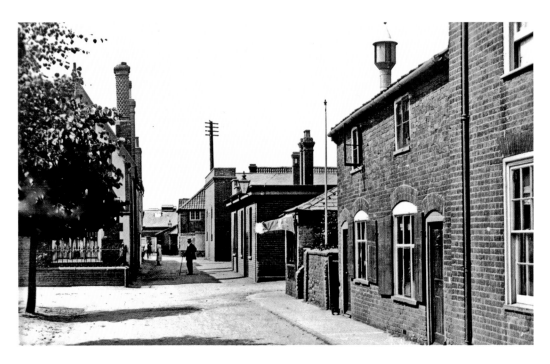

Chaucer Street

This depicts Chaucer Street at the junction with Popson and Scales streets. The Chaucer Institute can be seen on the right, built in 1908. In the modern picture of Popson Street, the taller building to the right of it was built on the site of the Butcher's Arms pub which closed in 1907, and the reception area for Clay's book-printing business is on the extreme right.

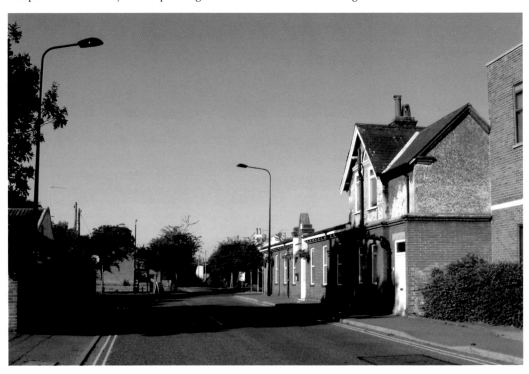

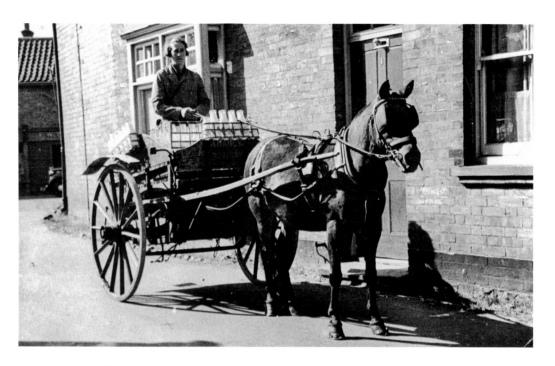

Corner of Chaucer Street and Earsham Street

A tranquil scene of Elsie Rattle delivering milk for Hancy's on a horse and cart in the 1940s. Traffic has changed considerably during the past decades, and Chaucer Street has now become one of the danger spots of the town, as huge vehicles like the Bernard Mathews' lorry attempt to negotiate the narrow bend.

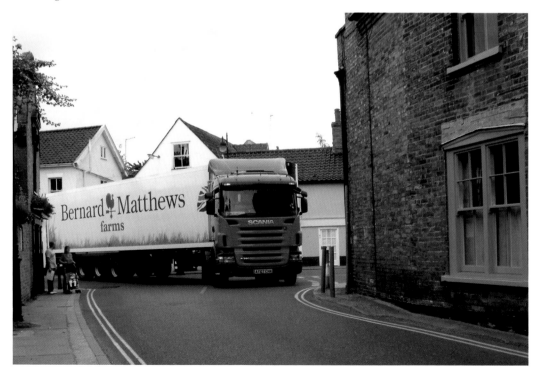

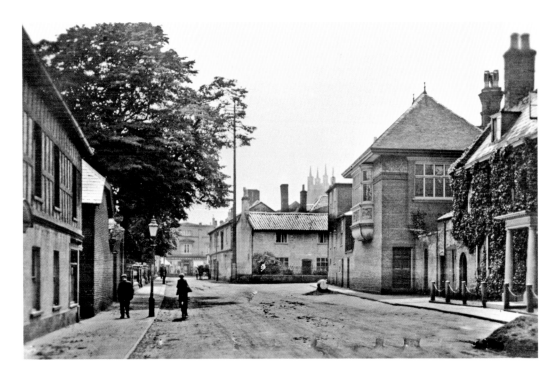

Broad Street

Wightman's shop in the Market Place can be seen at the end of the street, *c.* 1900. On the right stands the house and business premises of the solicitor Frederick Smith, which fronts Earsham Street. Today the property is owned by Waveney District Council. The Town Council meets in the room with the attractive lead glazed windows on the first floor, originally built as Fred's billiards room.

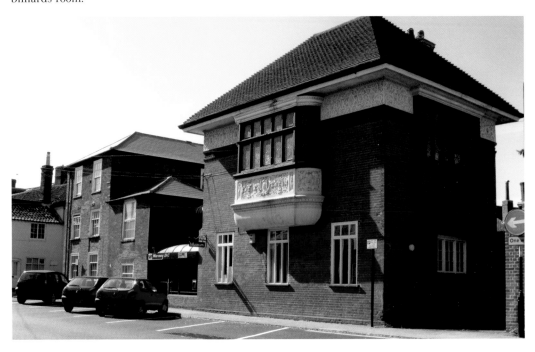

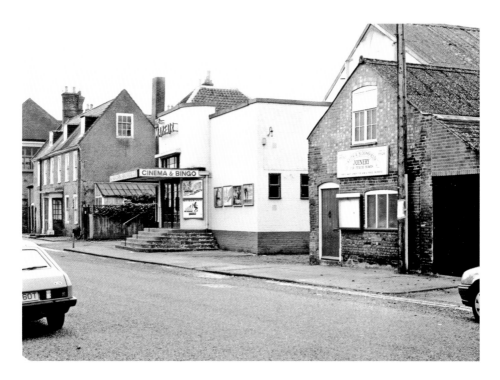

The Mayfair Cinema

The cinema opened in 1937, Bungay's first purpose built Picture Palace. Previously, films had been shown at the Fisher Theatre, after it had been converted into a Corn Exchange, across the street. The Mayfair was demolished in recent years, and replaced with residential properties. Today, the proverbial wheel has turned full circle, and the renovated Fisher Theatre has become the town's venue for films again.

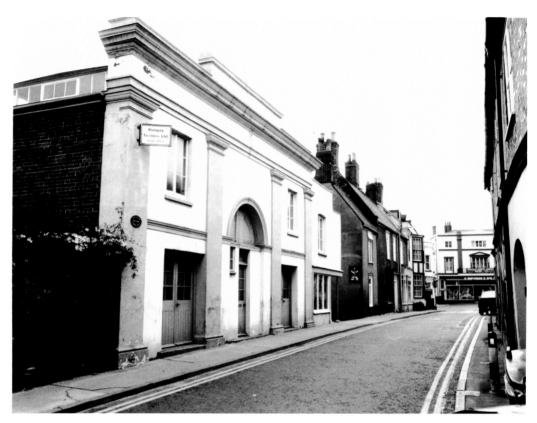

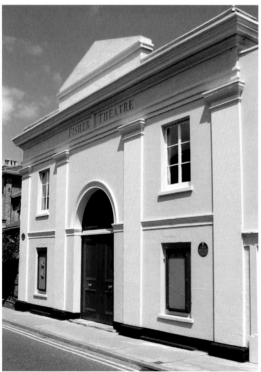

The Fisher Theatre

The theatre was built in 1828, one of a chain of small-town performing venues established by the Fisher family, who managed a company of touring players. The theatre closed in 1844, and was then used as a Corn Exchange, and for various social events and entertainments. During the later part of the twentieth century it was used for commercial businesses, until it was rescued by the Bungay Arts & Theatre Society, who have now transformed it into a living theatre again.

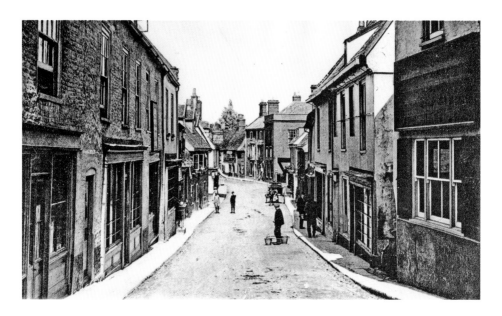

Bridge Street, Looking Downhill

The boy standing with his buckets has probably just been drawing water from the Borough Well, in the alley to the right. On the left is the Beaconsfield Arms pub, and further along, the Chequers, the only one of five pubs in the street to survive. When the photo was taken shoppers could buy everything they needed in the one street. Today it's mainly residential, and since it was made one-way for traffic, the houses have blossomed into bright colours.

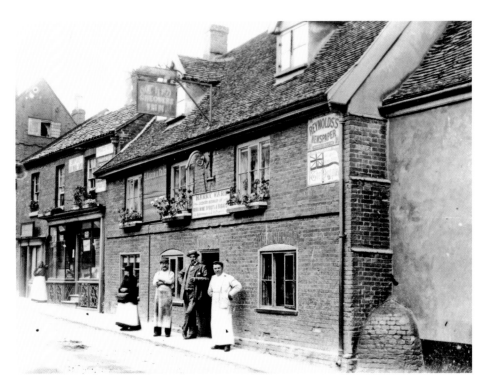

Chequers Inn, *c.* 1900

The landlord, Harry Ward is probably the man wearing a boater-hat standing in the doorway, flanked by his bar-staff wearing white aprons. The building dates back to the seventeenth century. Today it has a large car-park on the right, and has been freshly painted although in a rather more sober colour than other buildings in the street. But you won't find many sober customers inside on a Saturday night, as they enjoy its fine beers.

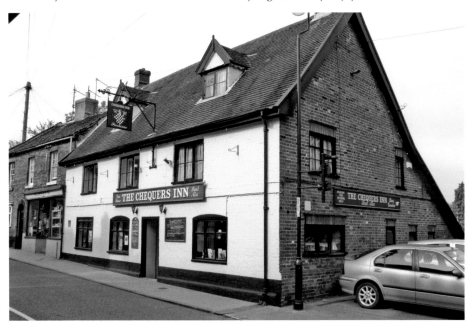

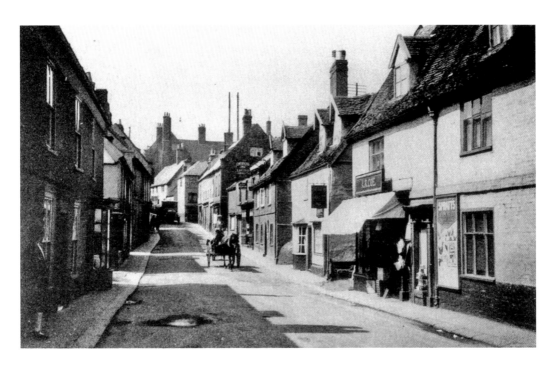

Bridge Street, Up-hill

Photographed in the 1920s, looking uphill with a large lorry blocking the road. Road blockages occurred regularly until the street became one-way for traffic a few years ago. Now, the atmosphere is greatly improved for both residents and pedestrians. In the modern picture, Ronnie Buck's premises displaying a variety of antiques and curios is on the left, with the Bungay Market Tolls board by the window. It's signed, 'P. J. Sprake, Town Clerk, 1922'.

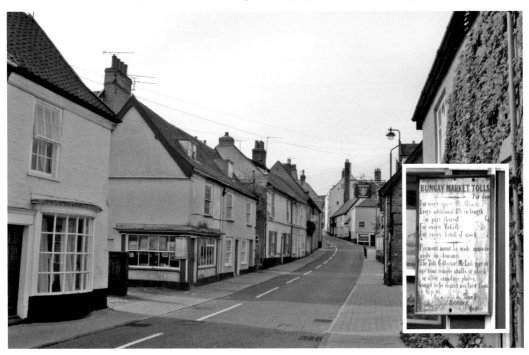

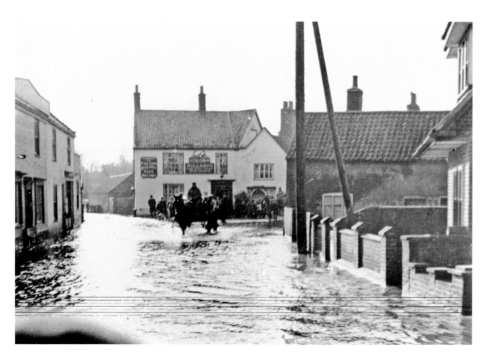

Ditchingham Dam, 1947

In the past this area used to flood quite regularly, and the extent of the flooding is depicted in this photo of the mid-twentieth century. The Falcon pub is just across the bridge separating Bungay from Ditchingham, so this is a Norfolk scene. Like several of the other buildings in adjacent Bridge Street, the old Falcon has recently been painted in attractive colours.

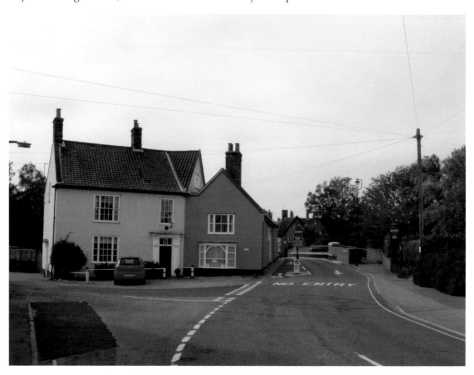

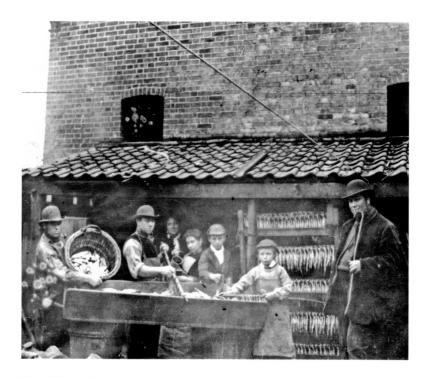

The Old Smoke House

The Smoke House was situated at the bottom of Bridge Street, in Wharf Yard. The property is close to the Staithe Navigation so conveniently placed for the delivery of fresh fish brought in from Lowestoft or other local seaside towns. The building fronting Bridge Street is now a private residence, and stands next to what was originally the ancient King's Arms public house, which also benefited from the river trade by providing boats for hire.

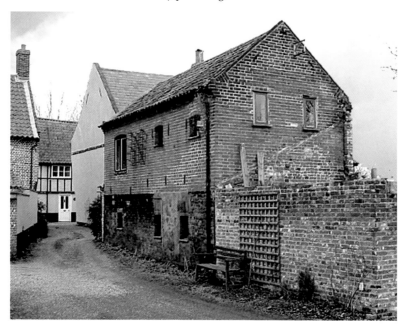

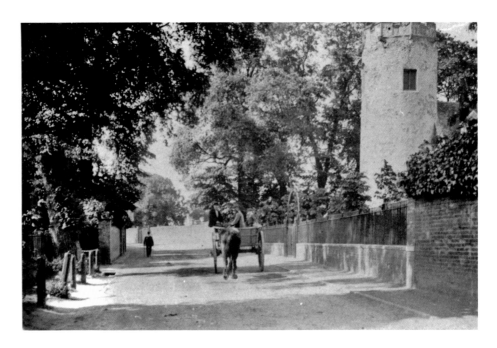

Trinity Street

Holy Trinity is the town's oldest building, with a round tower believed to date back to Saxon times. It survived both the dramatic lightning strike which damaged St Mary's church in 1577, and the Great Fire of 1688. The iron railings round the churchyard were removed during the Second World War when iron was needed for the manufacture of munitions. Following the closure of St Mary's for regular services in 1978, it remains the sole centre for Anglican worship.

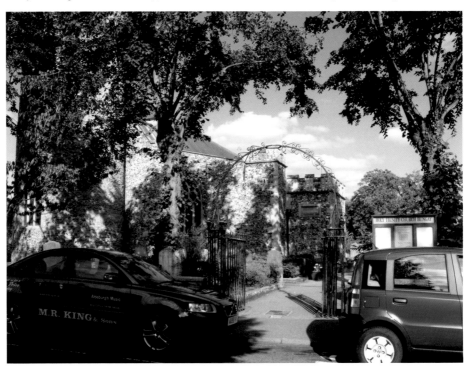

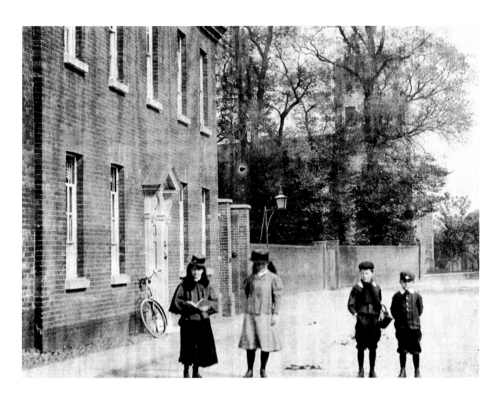

No. 19, Trinity Street

The building on the left was the surgery of G.P.s Dr Leonard Cane, and his son Hugh for the greater part of the twentieth century. It is now a private residence, and the town has been provided with a purpose built medical centre in St John's Road. It was established partly through the generosity of local benefactress Kathleen Bowerbank, who also provided funding for the new Library, and left a magnificent bequest for St Mary's church.

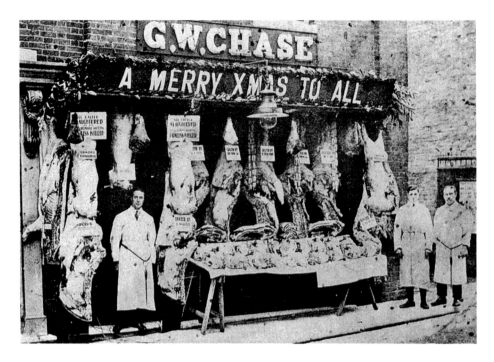

G. W. Chase's Butcher's Shop, Trinity Street

This display of Christmas meat seems totally unhygienic according to modern standards of food care, but at least there would be no flies to spread disease in the chilly December weather. There was concern for animal welfare at the time because the notice in the window states that cattle are slaughtered using a painless killer. The shop was next door to the Queen's Head, on the corner of Bridge Street. The building is now occupied by the National Westminster Bank, a much less messy business.

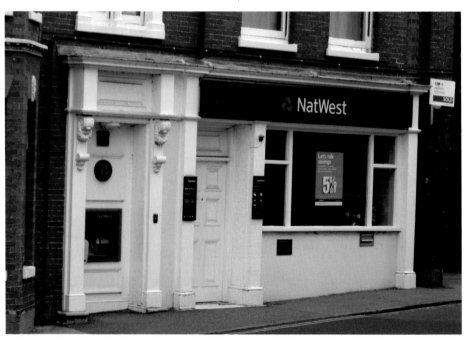

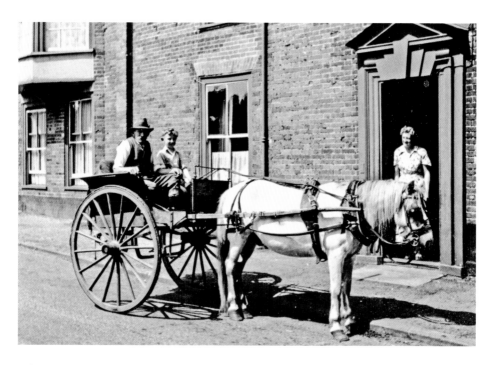

Wharton Street House

A horse and trap stands outside Wharton Street House. The building was used as the Bungay Collegiate School for boys towards the end of the Victorian period, usually referred to as the Brewers School, because Mr D. H. Brewer was the headmaster. Drill for the boys was provided by Sgt Daley, and the annual fee for boarders was 18 guineas. Today the property is a private residence, and the sound of the swishing cane and cries of pain are heard no more.

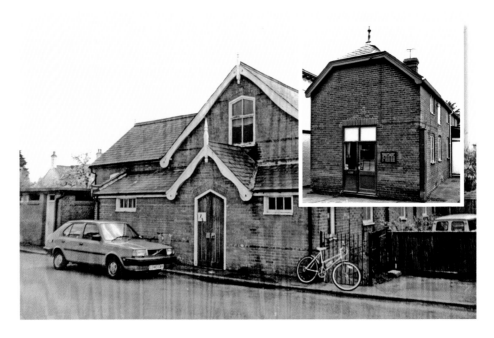

Trinity Rooms, Wharton Street

The building was not only used for Trinity Church social and fundraising activities, but for a variety of other community events. The left hand section had reinforced walls for use as an air-raid shelter during the Second World War, and proved difficult to demolish when the building was removed to provide a new library. It was officially opened in 1992, by the Hon. James Prior, M.P. and its benefactress, Kathleen Bowerbank. The inset shows the original town library which occupied a former stable-block in Broad Street, attached to the property now Barclay's Bank.

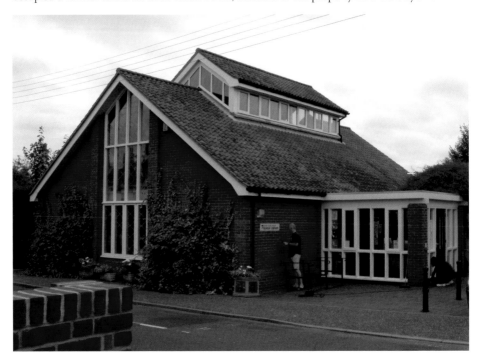

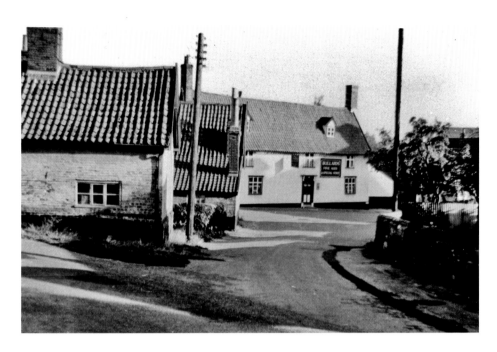

Staithe Road

The White Horse pub which dates back to the sixteenth century, can be seen in the background. The triangle of small houses on the left has been demolished and is occupied by a green area of trees and colourful daffodils in the spring. The pub closed in 1978, and is now a private residence. Note the large number of parked cars. The area becomes swamped with traffic in the mornings and afternoons when parents are driving their children to and from the primary school in Wingfield Street nearby.

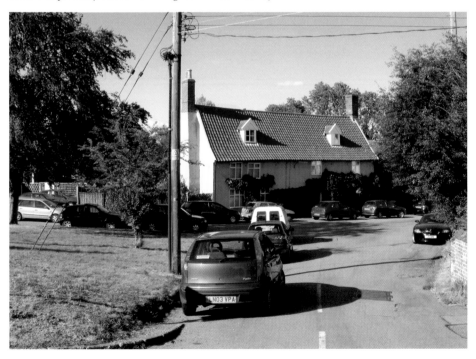

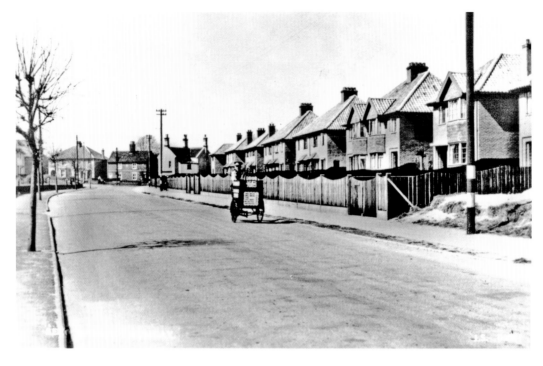

Beccles Road, *c.* 1945

Council houses were built on the left in the 1920s and the houses on the right were built in the 1930s. The house on the extreme right seems to be in process of completion. The sole vehicle in the road is a tricycle ice-cream cart, bearing the notice 'Stop Me and Buy One'. In those days, you could make yourself quite ill on ice-cream for a shilling.

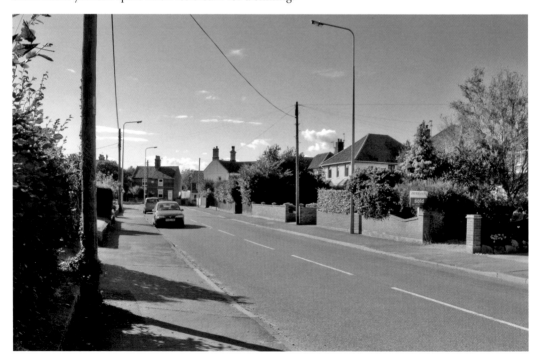

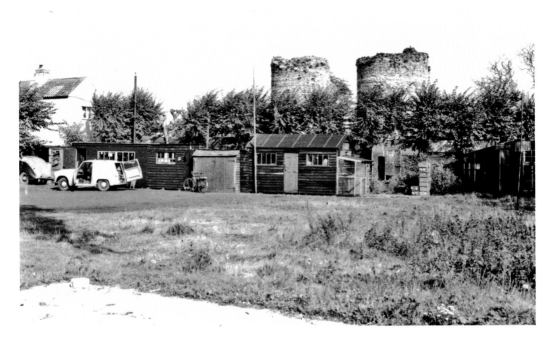

Bungay Castle

In the 1930s the inner bailey fronting the Castle gatehouse was used as a sale ground and livestock market. The sheds to the rear were probably provided for storage of equipment. Later on, the field was used for boxing tournaments and wrestling matches organised by Cliff Butler in the 1950s. Today, the gatehouse towers have just had the scaffolding removed following renovation work.

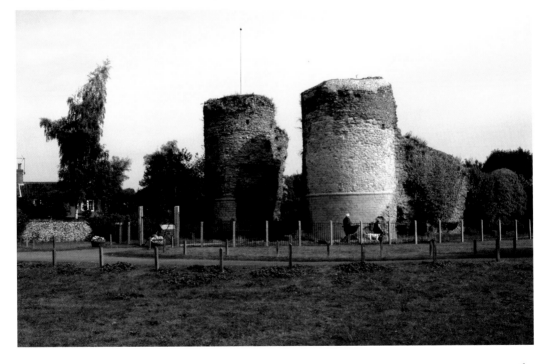

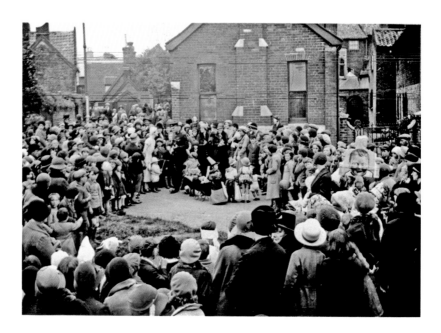

Castle Orchard

This large crowd of mothers and children is part of the Bungay Baby Welfare week, depicted in the Market Place photograph on page 8. The building to the rear is the old Court House, since demolished and replaced with a bungalow. The children in the centre are wearing fancy-dress and the little boy in the jockey's costume is the young Frank Honeywood. The site on the left is now occupied by 'Jesters', the café for visitors to the Castle.

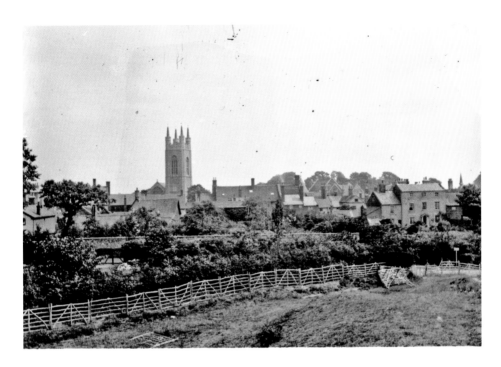

The Castle Hills

This was formerly part of the medieval Outer Bailey used for recreational purposes. In this photo of *c.* 1900 the paling fence suggests it may have been used for grazing livestock. In 1938 it was opened as a new public recreation area by the Town Reeve, Rosalind Messenger. The graceful tower of St Mary's adds grandeur to the scene, viewed in the rosy rays of the setting sun.

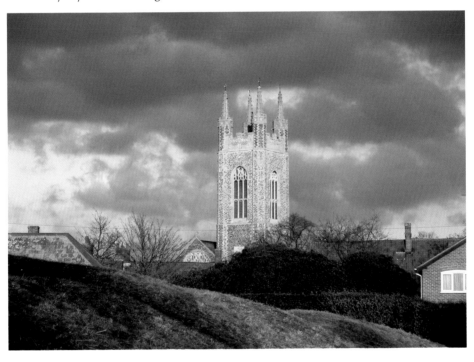

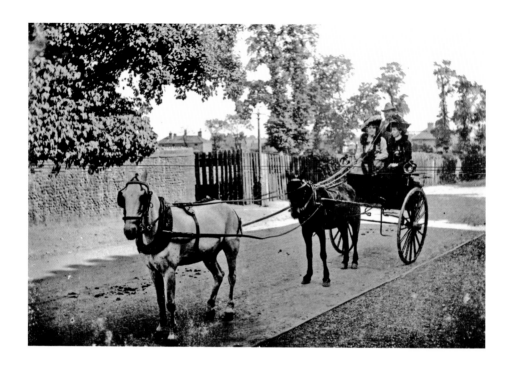

The Folly, Upper Olland Street

The narrow lane on the left is the Folly, *c.* 1900, which runs between Upper and Lower Olland streets. In the background can be seen the glebe land connected with Holy Trinity parish, which at the time was the recreational and grazing area known as Honeypot Meadow. It bordered on Bardolph and St John's roads. The meadow is now occupied by Olland Court residences, the bowls club, and the community centre.

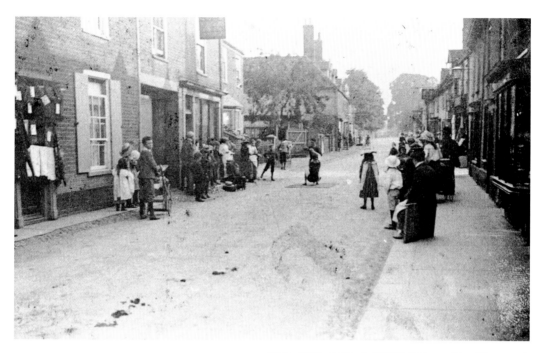

Upper Olland Street

A large crowd of children are gathered, and it seems they are watching two boys wrestling on a mat in the middle of the street. In those days there was no fear of traffic, the only danger might be a runaway horse, or a drunk cyclist. The building on the left near Turnstile Lane was the Queen pub, which has been recently converted into flats

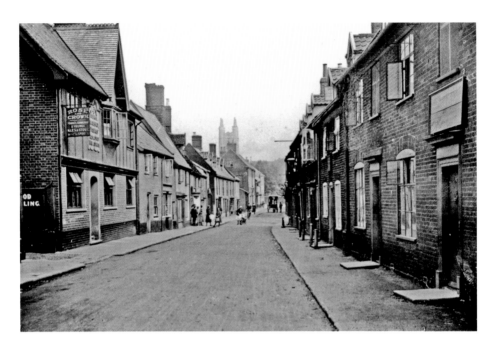

The Rose & Crown, Upper Olland Street

The tower of St Mary's church can be seen at the Market end of the street. The old Rose & Crown pub closed in 1969, and is now a private residence. The notice on the entrance gates to the left reads 'Good Stabling', an important feature for pubs and inns in the Victorian and Edwardian periods. Note the wide door-step slabs on the right connected with the row of eighteenth-century terraced houses.

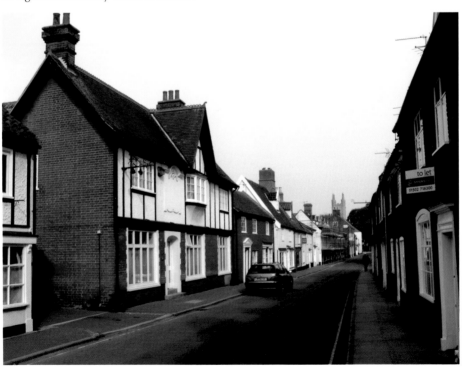

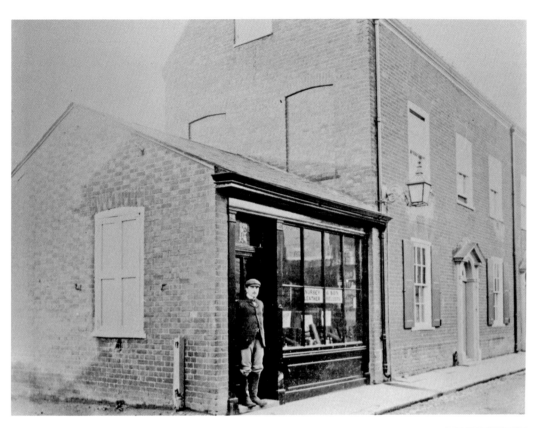

Nursey's, Upper Olland Street
One of Bungay's oldest businesses dating back to the late eighteenth century. The small notice in the window states 'Nursey & Son, Leather Goods', and today, the hanging sign advertises sheep-skin products. In *c.* 1900, the shop premises was a one-storey building, but in the late 20th century it was converted into two-storeys. More recently an attractive Victorian style window and door have been added to create a period façade similar to the original.

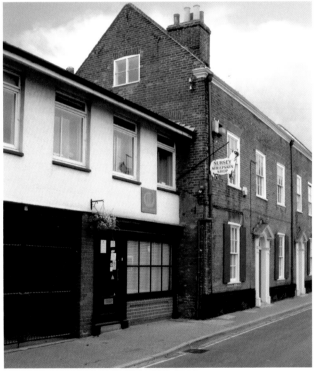

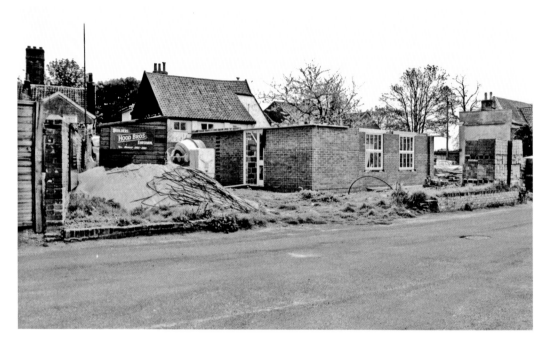

Boyscott Lane.
A new pair of houses is being built in 1981 designed by local architect Richard Balls. The site is part of the back garden of the Old Maltings in Upper Olland Street. The builders notice, 'Hood Brothers' can be seen on the left. The attractive properties are Kean Cottage, on the left and Cherry Tree Cottage on the right, which has an ancient cherry tree in the garden surviving from the former orchard of the Maltings.

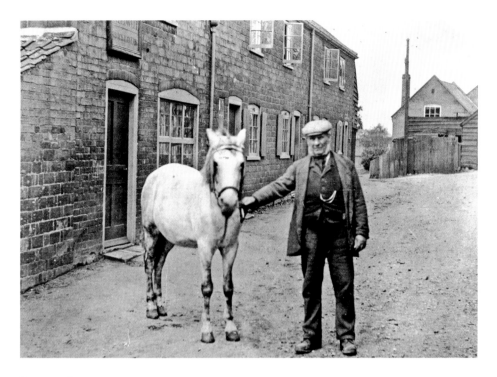

Boyscott Lane, *c.* 1930s

Mr Bedwell, a local builder poses with his pony, and his name can be seen on the board above the door of the cottage on the left. In the rear of the picture is the hall built for the Congregational Church, and now used by Emmanuel Church. Part of the building was used as an army cookhouse during the war. The Sunday School room was added in 1914.

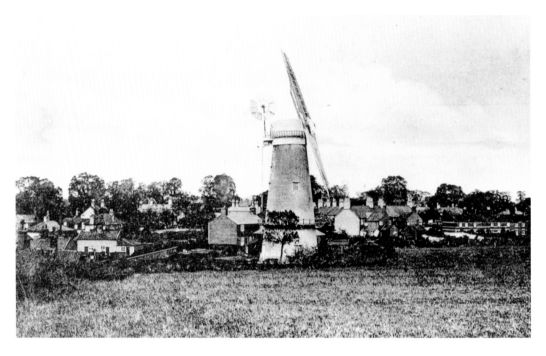

Tower Mill, Southend Road, c. 1900

Of the five mills which stood in the town in the nineteenth century, this is the only building to survive. The sails were severely damaged when they were struck by lightning in 1918, and in c. 1924, the property was converted into a house for Mr C. H. Lockitt, headmaster of the grammar school. The footpath sign in the colour photo is for the 'Ups & Downs'.

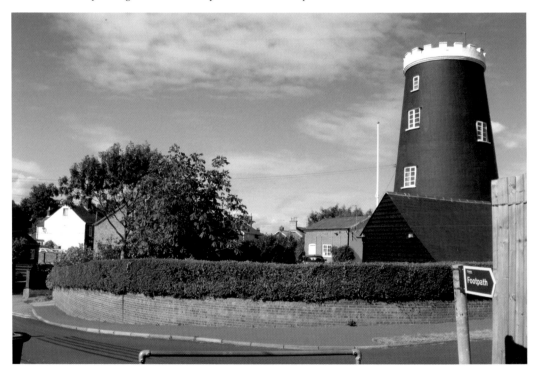

Southend Road

The cows which have probably been grazing on the meadow in St John's Road, are returning in the evening perhaps to a farm in Flixton Road. In *c.* 1900, Parrivani's the ice-cream family, lived in the cottage on the corner of Southend Road and Laburnum Road, and grazed cows on the meadow to the rear to produce cream for their delicious ice-creams. Southend Road has changed a lot in recent years and most of the attractive Gothic style windows in these terraced cottages have been replaced, and front-gardens replaced with car-parking spaces.

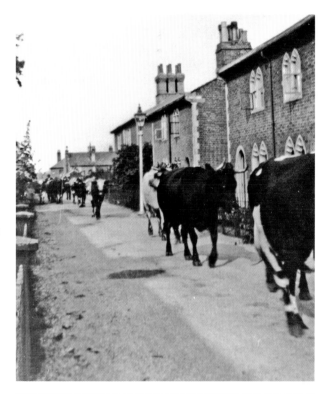

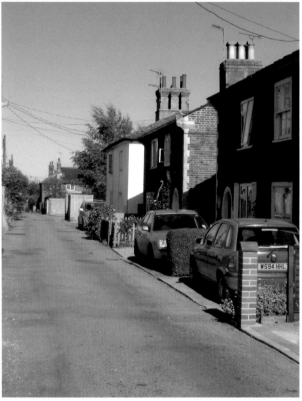

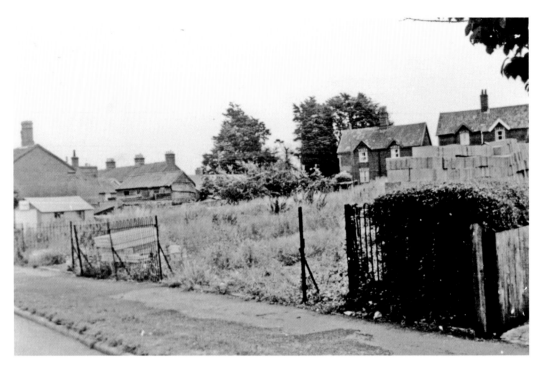

Pennyfields, Flixton Road, 1967

Work has commenced to build the cul-de-sac of houses known as Pennyfields in Flixton Road. The land backs onto the former Jubilee Road playground, created by Town Reeve Guy Sprake in 1937, commemorating the coronation of George VI. The houses along the 'Ups & Downs' can be seen in the background.

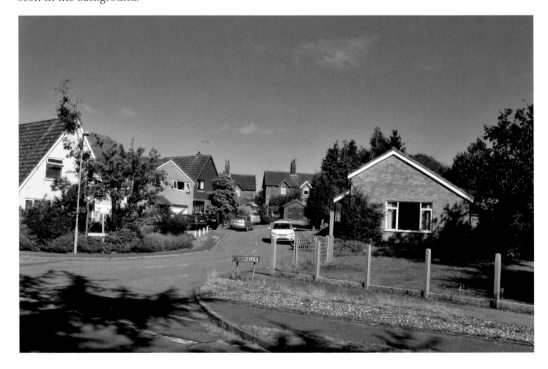

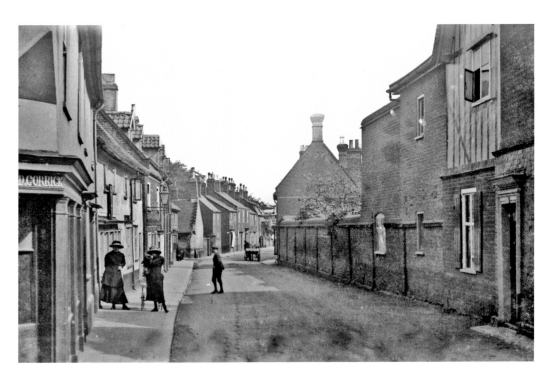

Lower Olland Street, *c.* 1900

The Angel pub is on the left, and next to it, on the site of what is today 'Dinky's Garden' was the White House Farm dairy. The steeply pitched gable end of the Christian Wharton Almshouses can be glimpsed on the left further down the street. Most of the buildings on the left were demolished in the 1970s to create the Wharton Street car-park

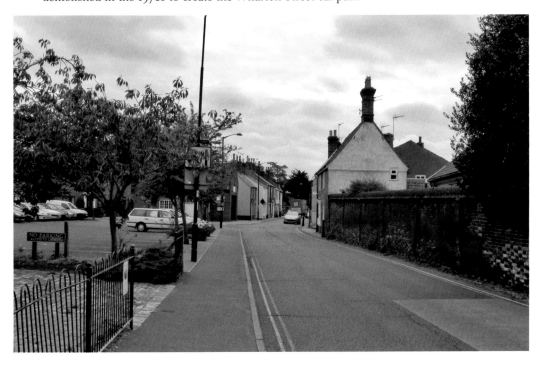

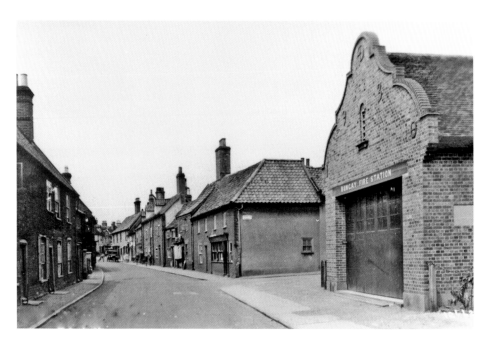

Lower Olland Street, Looking Towards St Mary's Street
This photo was taken in about 1938, and the fire station built in 1930, has replaced the Wharton Almshouses. Although a motor-car can be seen at the end of the street, motor-traffic made little real impact until after the Second World War.

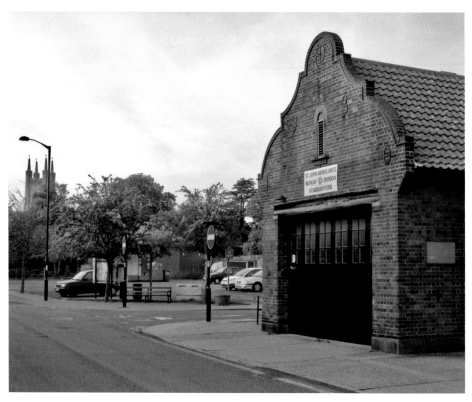

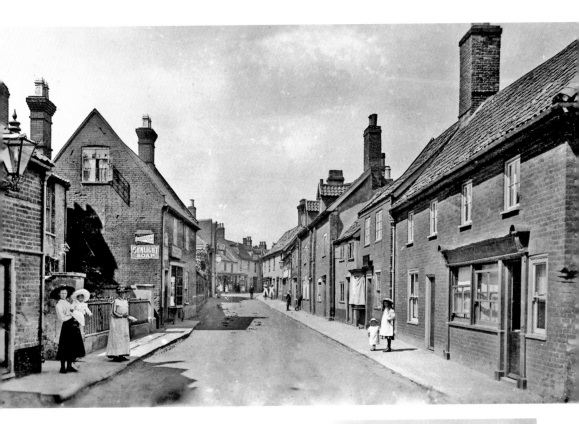

Lower Olland Street,
c. 1900

The houses and shops demolished to make way for the car-park can be clearly seen on the right. Horse manure in the road indicates that motor-power hadn't yet replaced horse-power. The old lady on the left has come out to buy a ha'porth of sugar for her tea from the shop opposite. She is wearing her pinny and slippers but wouldn't be seen dead in the street without a hat.

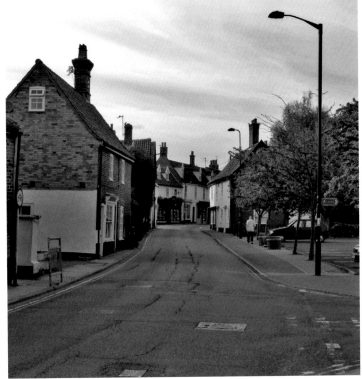

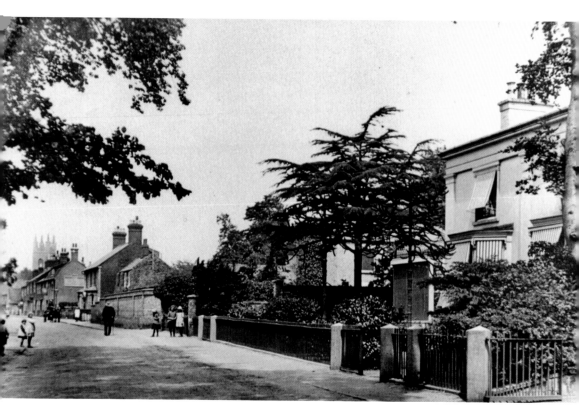

Lower Olland Street, Olland House

The handsome house on the right was the property of William Walker who owned the Staithe navigation. It had wonderful gardens to the rear, and children were fascinated by the monkey-puzzle tree in the front garden, 'the only tree a monkey can't climb'. The house was later 'Dunelm' a boarding – house for pupils at Bungay Grammar School. The property is now occupied by the printing firm PDQ.

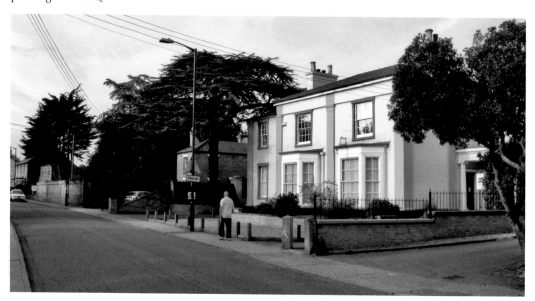

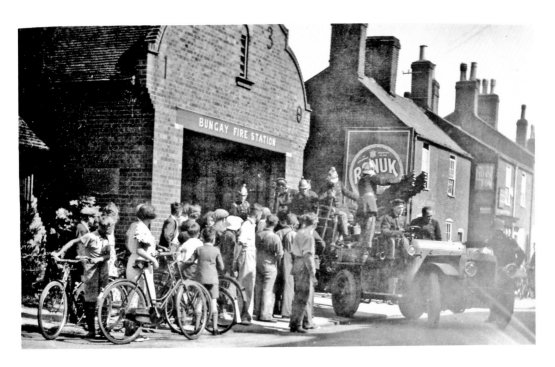

Fire Station, Lower Olland Street

The fire-engine, drawn by a large car, is leaving the station, watched by a large crowd. Well, there was no television in those days. 'Miss Raven's' shop is on the right, with the Lions Tea sign displayed on the wall. It sold sweets and groceries, and was used as a tuck-shop by the grammar school boarders, but Miss Raven hated boys, and viewed them all with suspicion. A new purpose built fire-station is now situated in Old Grammar Lane.

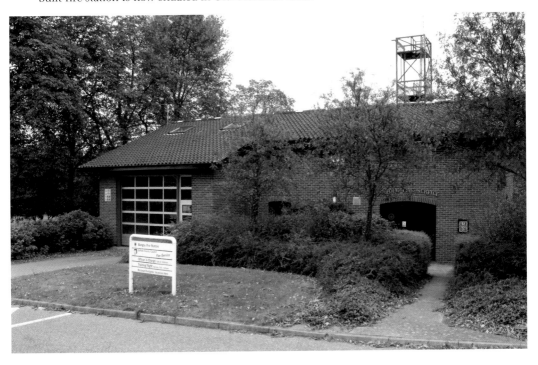

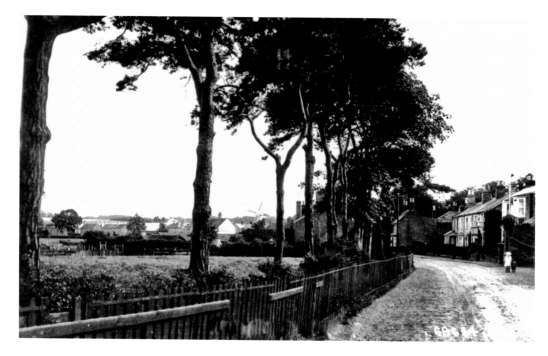

Wingfield Street

It's difficult to imagine today, but a hundred years ago, only one half of Wingfield Street was occupied by buildings, and the area opposite the Council School, now the primary school, was allotments and fields. One of Bungay's five windmills can be seen in the distance. The conifers in the garden of No. 38 are rare survivors of the earlier period.

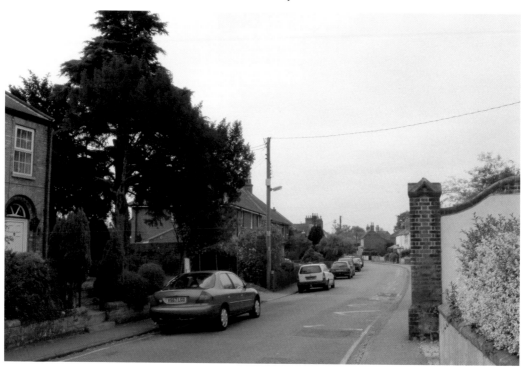

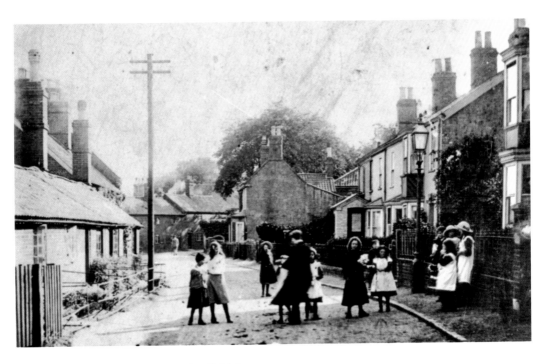

Council School Children, Wingfield Street

The children have perhaps just finished afternoon school, and the girls are wearing straw summer hats. Note the buildings in the background, which were demolished in the 1950s, and the area has since been developed into a cul-de-sac of modern houses. The Plough Inn stood on the left, the last thatched property in the town, and originally the street was known as 'Plough Street'.

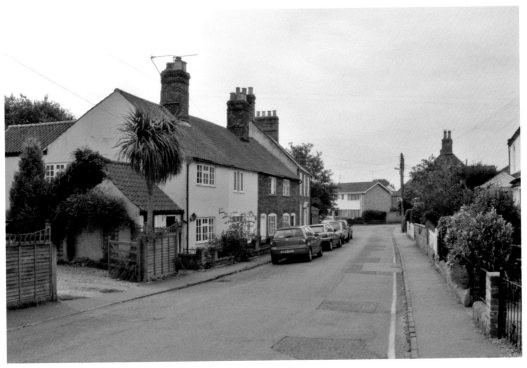

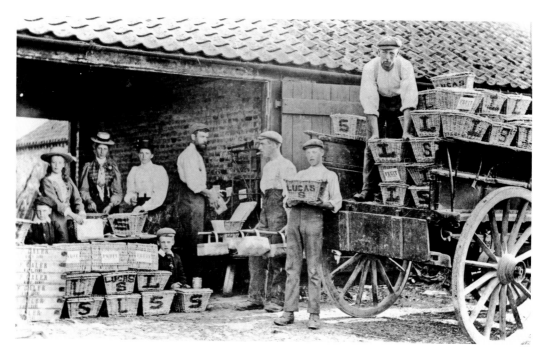

Wingfield Street House

The Lucas family, who ran a fruit business, are unloading their baskets of fruit at the side- gates of Wingfield Street House. Even the youngest members of the family seem to be involved. Surely they should be across the road doing their sums in the Council School? The colour photo depicts the side-building to the right.

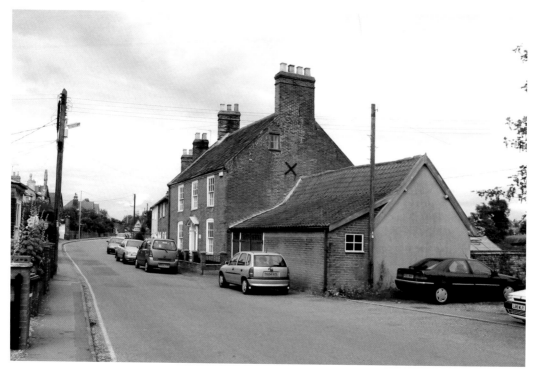

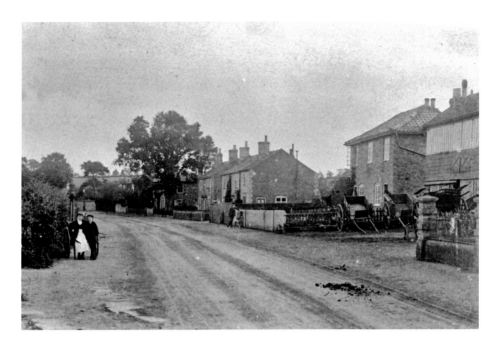

St John's Road

This wonderful period view, of *c.* 1900, shows the road before the terraced houses were built on the left. On the right are the premises of Cuddon's carriage works, the site which today is occupied by Charlish's garage. The boy with his bike stands near the Southend Road turning. Until recently, this part of the road was occupied by Three Willows Garden Centre which has now moved to Flixton Road.

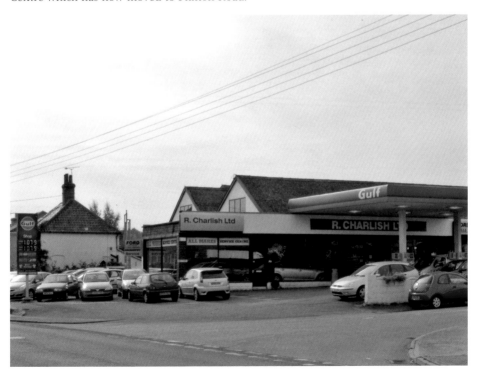

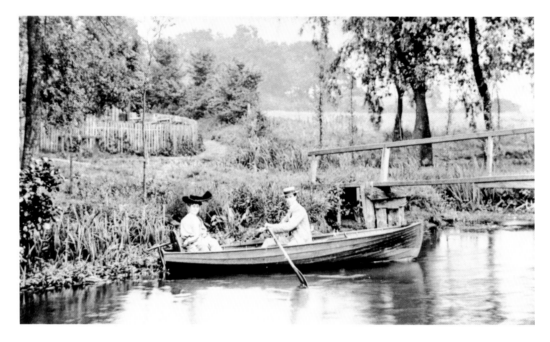

Outney Common: the River Waveney

The Waveney around Bungay is no longer navigable for large craft but remains popular for rowing-boats and canoes. The couple in the photo of *c.* 1900 probably hired their boat from Baldry's boatyard across the river in Ditchingham. The modern photo depicts brightly coloured fibreglass canoes at the Staithe, where the Bungay & District Canoe Club has its headquarters at the Staithe Riverside Centre.

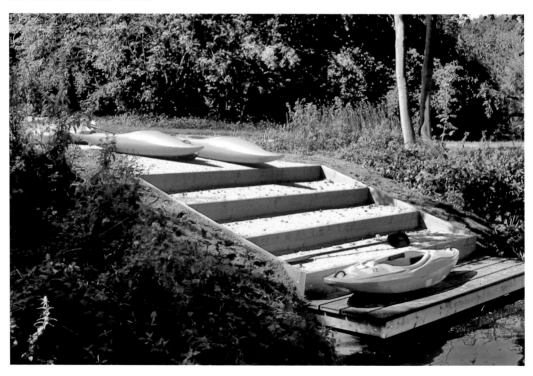

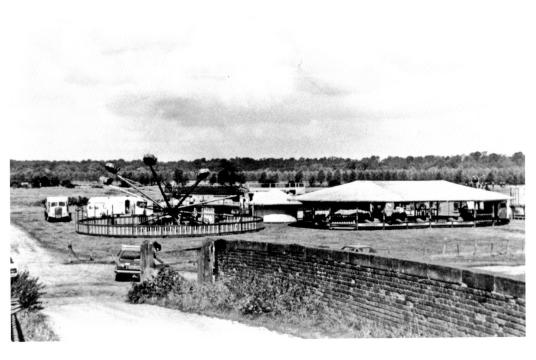

Fair and Circus on Outney Common
The fun-fair on the Common in *c.* 1980 contrasted with the gaily striped marquee of the Circus Tyanna in 2009. The old railway bridge can be seen in the foreground of the earlier photo. In 1983, it was replaced by a modern footbridge over the by-pass.

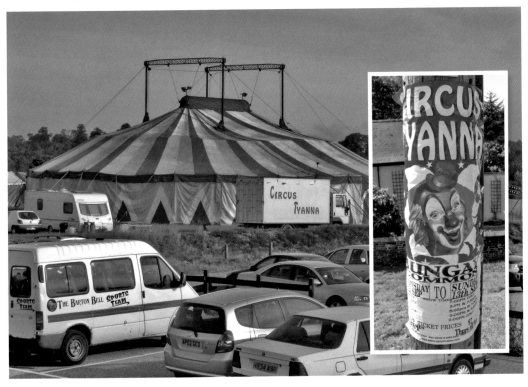

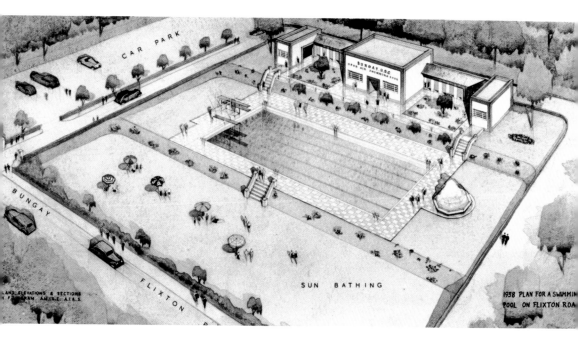

CAR PARK

BUNGAY

FLIXTON

BUNGAY U.D.C.
OPEN AIR SWIMMING POOL

SUN BATHING

PLANS, ELEVATIONS & SECTIONS
F. INGRAM A.M.I.S.E.

1938 PLAN FOR A SWIMMIN
POOL ON FLIXTON ROA

Bungay Swimming Pool

The architect's drawing shows a design for an open-air swimming pool, planned for Flixton Road, and designed by F. Ingram in 1938. The plans never developed due to the outbreak of the Second World War a year later. Today, Bungay has a superb indoor swimming pool, on St John's Hill, the envy of all the other towns around.

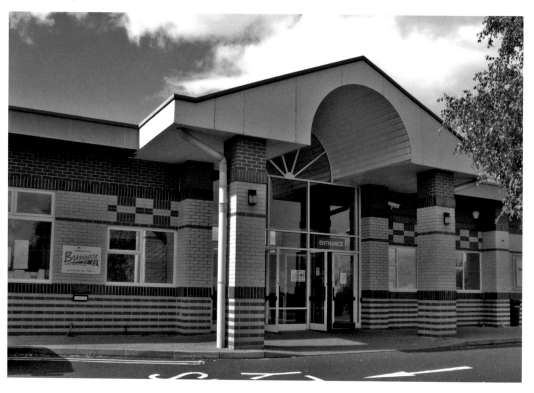

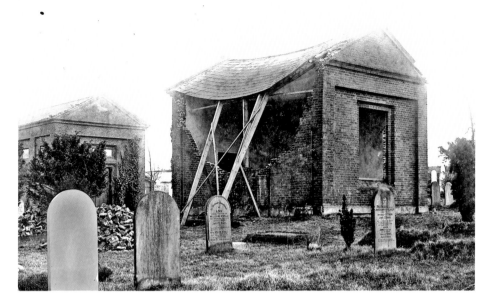

Bungay Cemetery, Hillside Road

The Cemetery,established in the late nineteenth century, originally had three mortuary chapels. In 1908, a rare hurricane occurred which blew down the north wall of one of them, and it was demolished soon afterwards. The other survived until 1984. The sole survivor today has recently suffered regular vandalism, and when the roof-slates were repaired by Waveney District Council they were smashed again. But we've got our eye on you 'Julian M'.

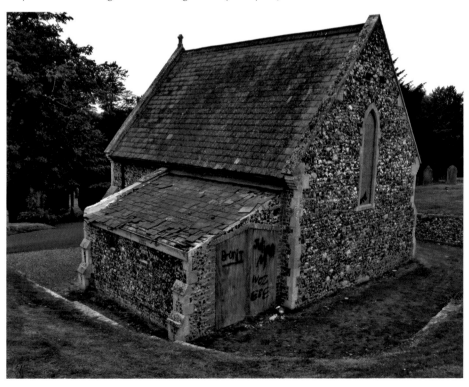

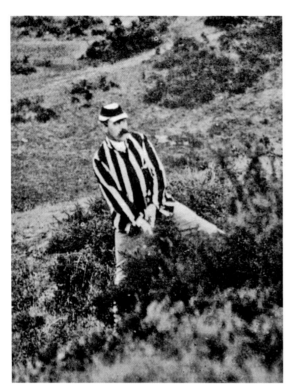

Bungay Golf Club
Is the dashing chap in his striped cap and blazer a genuine golfer, or a male model advertising a natty outfit which could be purchased from C. H. Payne's outfitters? A 'snip' for only two shillings and elevenpence . We shall never know, but natty sporting gear can be purchased today from the modern golf club shop.

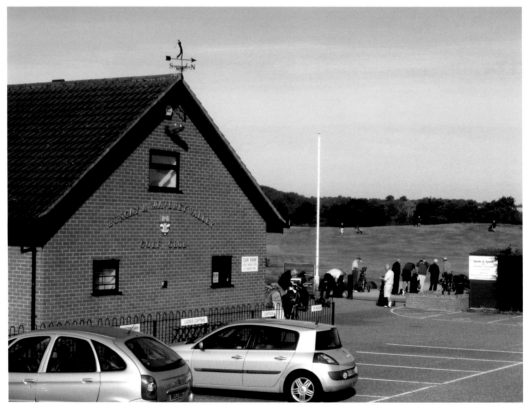

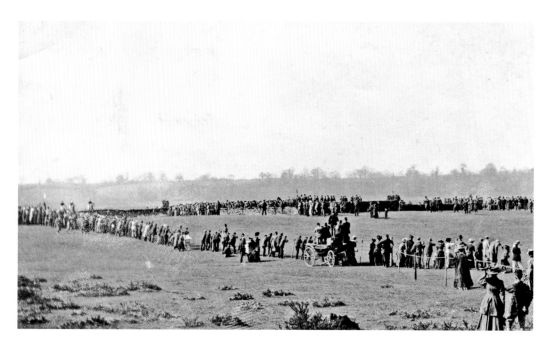

Bungay Races on the Common, 1909

The annual races were a major sporting event for centuries, attracting massive crowds from throughout the region. The last event took place in 1957, and today the race-course is the golf-course, representing a rather more leisurely sport. This book commenced with the Great Fire which devastated the town in 1688, and ends with this peaceful view of white clouds scudding over one of Bungay's greatest assets – the Common.

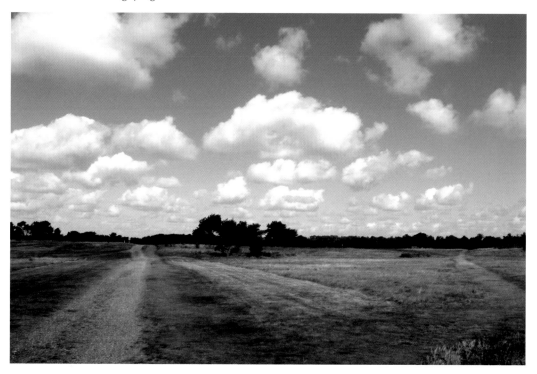

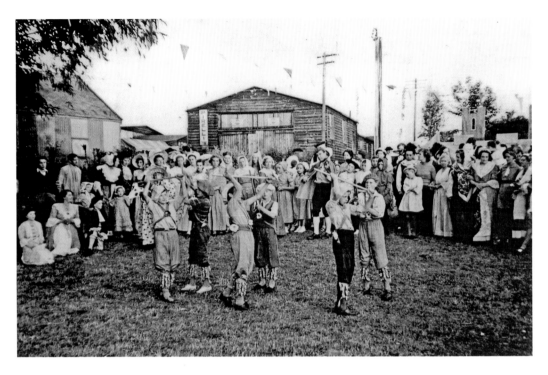

An event on the Castle Hills for Bungay Pageant week, in 1951.

Acknowledgements

Grateful thanks to all those who, over the years, have contributed to the Frank Honeywood collection of photographs, now housed in Bungay Museum.